A Guide to Historic

Beaufort

South Carolina

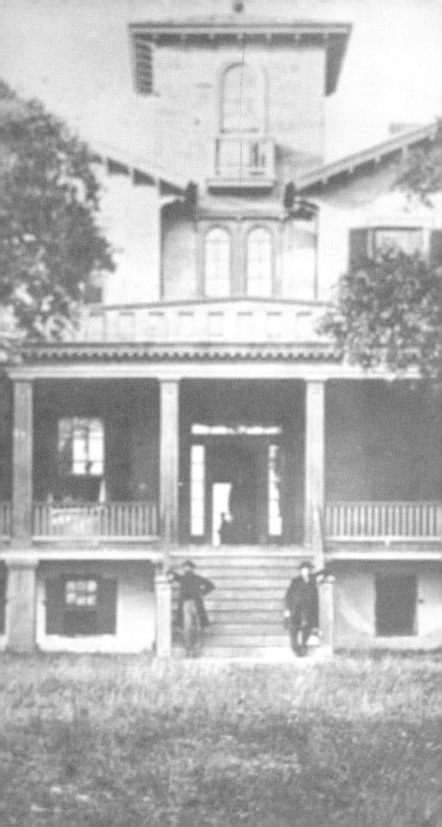

A Guide to Historic

Beaufort

South Carolina

Alexia Jones Helsley

Charleston London

History
PRESS

Published by The History Press
Charleston, SC 29403
www.historypress.net

Cover Image: Oyster Flats, William McCullough.
Frontispiece: Tidalholm, ca. 1861. *Courtesy Library of Congress.*

First published 2006

Manufactured in the United Kingdom

ISBN 1.59629.045.5

Helsley, Alexia Jones.
 A guide to historic Beaufort, South Carolina / Alexia Jones Helsley.
 p. cm.
 Includes index.
 ISBN 1-59629-045-5 (alk. paper)
 1. Beaufort (S.C.)--History. 2. Beaufort (S.C.)--Biography. 3.
Beaufort
(S.C.)--Guidebooks. 4. Historic sites--South
Carolina--Beaufort--Guidebooks. 5. Historic buildings--South
Carolina--Beaufort--Guidebooks. 6. Dwellings--South
Carolina--Beaufort--Guidebooks. 7. Beaufort (S.C.)--Buildings,
structures,
etc.--Guidebooks. I. Title.
 F279.B3H49 2006
 975.6'186--dc22

 2006020023

Notice: The information in this book is true and complete to the
best of our knowledge. It is offered without guarantee on the part of
the author or The History Press. The author and The History Press
disclaim all liability in connection with the use of this book.

Contents

Preface

Historic Beaufort is a living organism. It is not a buried artifact like Herculaneum or Pompeii frozen in time. The houses and other properties described in this guide have evolved and changed over time. Dating them can be problematic. Antebellum Beaufort County records such as deeds, wills and estate settlements were lost during the Civil War, possibly when Columbia burned in February 1865. So there are few sources to document construction and confirm ownership.

The properties have suffered the ravages of time, hurricane, fire and occasionally flood. Their appearances have changed as owners have renovated or adapted older structures to new architectural fashions. As a result, dating many of these structures is conjectural and the visitor will find at times widely varying dates and data for the same property. This guide attempts to present the best information available. That does not mean that new architectural evaluations or archaeological or documentary finds will not change it.

While a property may appear on more than one tour, in general, the entries are not duplicates. As a result, the author suggests reading all the tours in order to more fully appreciate the diverse and complex characters that once walked on Beaufort's stage.

The city of Beaufort and her proud historic treasures with proper planning and protection will continue to entrance and delight visitors for generations to come.

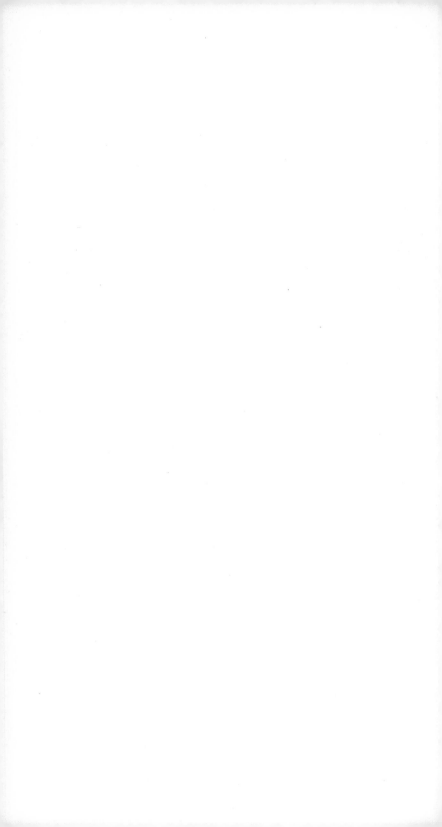

Acknowledgements

I gratefully acknowledge the encouragement of Jason Chasteen, Brittain Phillips and Julie Foster of The History Press and the assistance of Jacob Helsley, photographer. I am particularly grateful to William Benton who shared his postcards of old Beaufort, Uel Jones who provided other images and graphic artist Tim Belshaw who created the tour maps. I also appreciate the assistance of Grace Morris Cordial, Beaufort County Library; Marion Chandler and Ben Hornsby, South Carolina Department of Archives and History; and Beth Bilderbeck and Allen Stokes, South Caroliniana Library, University of South Carolina.

Beaufort—An Outline History

Nestled among the live oak, Beaufort is the "Queen City of the Sea Islands." The beauty and tranquility of the setting have captured the hearts of visitors for centuries. There is a timeless quality to Beaufort. The city sits as a gem on a curve of the Beaufort River.

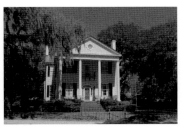

E.A. Scheper House (1411 Bay Street). Scheper built this Victorian home in 1893. *Courtesy of Jacob Helsley.*

A planned city, in 1711 designers laid out its streets on a grid. Generally, streets run north-south or east-west. Originally, the city boundaries were Hamar Street on the west; Duke Street on the north; East Street on the east; and to the south, the Beaufort River. In 1785 Boundary Street became Beaufort's northern boundary. Later in 1809, Beaufort added the Point and its eastern boundary became the Beaufort River. The original plan included a public square at the intersection of Carteret and Craven Streets. This area was known as Central or Castle Square. It may have been the site of an early fortification. The former Carnegie Library (now a city office building) occupies the northwestern corner of this intersection.

The area to the east of the original layout was known as the Point or Black's Point. To the north of Duke Street lay the glebe land for St. Helena Parish. In 1717 the South Carolina Commons House of Assembly approved a grant of fifty acres of the "said tract of land commonly known as Beaufort" for the support of the rector of St. Helena Parish.

Many of Beaufort's historic homes and public buildings reflect the prosperous days when sea-island cotton was the finest in the world. Yet despite its physical and natural beauty, the city of Beaufort faced many obstacles. On several occasions, the gem was almost lost to natural disasters and invasion.

Plat for the Reverend Lewis Jones, first rector of St. Helena, showing house facing the bay, 1739. *Courtesy of South Carolina Department of Archives and History.*

European fascination with the Beaufort area began in the sixteenth century. Spanish explorers visited the coast and in 1562 Jean Ribaut led a band of French Huguenots to establish Charlesfort on Parris Island. The rivalry between the French and Spanish for control of the Carolina Lowcountry ended badly for the French. The Spanish built Santa Elena on Parris Island and occupied the area (with one interruption) from 1566 to 1587.

Despite Spanish control, the English pursued their 1497–98 claim to the eastern seaboard. By 1670 the first English settlers landed in South Carolina. Charles Town, the first settlement, grew and settlers moved inland seeking new lands to cultivate, new homes for their livestock and new economic ventures, particularly trade with the Native Americans.

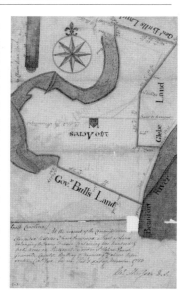

Pre-Revolutionary plat for John Fraser. Fraser, a Beaufort merchant, was a Loyalist and the State of South Carolina confiscated his property. *Courtesy of South Carolina Department of Archives and History.*

Within a few years, these new Europeans were in Beaufort County. The momentous year of 1684 brought both a new Scots settlement and the arrival from Florida of the Yemassee Indians. Spanish raids ended the Scots settlement of Stuart Town and Indian trade abuses led to a major uprising of the Yemassee, Creek and other Native American groups in 1715.

The Yemassee War was the first major threat to efforts to build a port town at Beaufort. Settlers such as John Barnwell and Henry Woodward lobbied for the new town, as they needed outlets for their produce and cattle. Cattle raising was a major source of income for Beaufort County's first English residents. These lobbying efforts bore fruit in 1711 when the Board of Trade authorized the town of Beaufort. The South Carolina Commons House of Assembly created St. Helena Parish in 1712.

The Yemassee went to war on Good Friday 1715 and attacked the Carolina delegation in their midst. Most died, but one—Seymour Burroughs—though badly injured, escaped and warned the settlers on Port Royal Island. The settlers boarded a ship in Beaufort Harbor and sailed to Charles Town.

With legislative encouragement, Carolinians returned to Beaufort. The residents built St. Helena Episcopal Church in 1724. The town grew slowly with its commercial district on Bay Street along the river. Life in the Carolina Lowcountry was uncertain. The Spanish in Saint

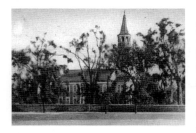

St. Helena Episcopal Church (501 Church Street). Despite the ravages of war, this structure still retains many of its handmade windowpanes. During the Civil War, Federal forces used the church as a hospital (no. 12). They removed the pews, organ pipes and balcony and built a second story across the nave. Tombstones served as operating tables. *Luther's Pharmacy, courtesy of William Benton.*

Augustine encouraged and led Yemassee raids of Lowcountry plantations. The Spanish also sent agents provocateurs to incite unrest among the slave labor force.

However, in time, the settlement of Savannah in 1733 and the growth of the colony of Georgia brought a buffer between the Carolina Lowcountry and the Spanish. With these developments, raids by the Yemassee and Spanish declined. The Beaufort area settlers breathed a collective sigh of relief and focused on trade and agriculture. Area residents produced indigo and in the years leading up to the American Revolution, some planters were growing rice.

In 1772 Beaufort had a brief moment of prominence. The British Governor Charles Montagu, in an effort to control an unruly Commons House of Assembly, moved the meeting place of the assembly from Charles Town to Beaufort. His plan failed because all the legislators showed up in Beaufort. Disgruntled, Montagu adjourned the proceedings and reconvened in Charles Town. His action was a factor in his being recalled to England and led to a specific complaint in the Declaration of Independence against holding assemblies in inconvenient locations. Montagu convened the Beaufort Assembly in the recently constructed Beaufort District Courthouse (now the site of the Arsenal). Beaufort's brief time in the political spotlight led not only to Montagu's recall, but the ensuing controversy also strengthened the Revolutionary party in South Carolina.

The Revolution was another crisis time for Beaufort. While Patriot forces successfully repulsed the first British incursion in 1779, the untimely destruction of the guns at Fort Lyttleton left the town defenseless. As the British turned their focus to the Southern colonies, Beaufort lay in the line of fire. British forces subdued Savannah in 1778 and then occupied Beaufort in 1779 as they planned their successful attack on Charles Town in 1780. Augustine Prevost, the leader of the British forces on Port Royal Island, liked Beaufort. He praised the healthful climate and set up a hospital there for wounded and ill British soldiers. According to intelligence received by Patriot General William Moultrie in 1779, the British had "landed their sick and wounded and placed them in the courthouse and gaol, which they have converted into hospitals." Prevost's headquarters stood at the corner of Carteret and Port Republic Streets.

The Beaufort area produced both Patriot and Loyalist leaders. On one hand, Thomas Heyward Jr., who signed the Declaration of Independence, lived at White Hall Plantation (now Jasper County) about twenty-five miles northeast of Savannah. Heyward fought at the battle of Beaufort (Port Royal Island) and was later imprisoned by the British. On the other hand, a member of

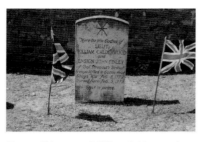

Grave of Lieutenant William Calderwood and Ensign John Finley, churchyard of St. Helena's Episcopal Church (501 Church Street). *Courtesy of Jacob Helsley.*

the leading Loyalist family, the Deveauxs, claimed responsibility for the burning of the parish church of Prince William's Parish at Sheldon. In 1782, the South Carolina General Assembly confiscated the Deveaux property.

The British left South Carolina in 1782 and the American negotiators signed the Treaty of Paris in 1783. The end of the American Revolution brought rejoicing and renewed challenges. Beaufort faced a serious economic crisis. Many of its Loyalist merchants and professional men had fled the colony. Thousands of Lowcountry slaves either fled to British lines or escaped during the war years and American independence brought an end to the British subsidy that made Carolina indigo profitable. Area planters needed a new cash crop to restore prosperity to the region.

In the post-war years, rice production spread to the Savannah River. Planters harnessed the tides to make rice even more productive. Also, during the 1790s, the introduction of sea-island cotton gave former indigo producers a new cash crop. With the coming of cotton cultivation, Beaufort was poised for its most prosperous period to date. Cotton money built the stately homes along Beaufort's tree-lined streets, fueled the mercantile development along Bay Street and created one of the largest antebellum black majorities of any district in South Carolina.

Planters bought slaves from Senegambia, Angola and other areas of West Africa to the Carolina Sea Islands. Given the unhealthy climate of the Carolina Sea Islands, these planters built town homes in Beaufort or in other inland retreats. Many families, like the Elliotts, annually returned to Beaufort in May for the summer months. As a result

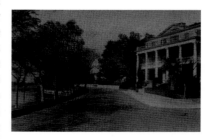

Bay Street with George Parsons Elliott House on the right. *Luther's Pharmacy, courtesy of William Benton.*

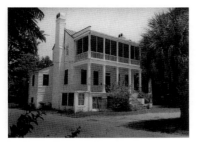

Daniel H. Bythwood House (711 Prince Street). Bythwood was an English sea captain who, influenced by his wife, became a Baptist missionary to the Sea Island slaves. Bythwood served as pastor, possibly on an interim basis, of both the St. Helena Baptist Church and the Baptist Church of Beaufort. *Courtesy of State Historic Preservation Office, South Carolina Department of Archives and History.*

of such prolonged absences, the slave workforce on the Sea Islands was largely self-sufficient. This isolation contributed to the development of the vibrant Gullah culture, a blend of African and European traditions.

During the 1830s and 1840s, the fallout from the Second Great Awakening enlivened the religious life of the town. St. Helena Episcopal Church expanded and in 1844, the Baptists built a new sanctuary at the corner of Charles and King Streets. The 1850s brought a building boom to the town of Beaufort. Wealthy planters built magnificent houses such as the Anchorage or the Castle along the bluff or on the Point. With great fanfare, the trustees of Beaufort College erected and dedicated new facilities and the Arsenal was rebuilt.

The Beaufort area was in the forefront of the secession movement. The Bluffton Movement in 1844 was an early precursor of secession as Beaufort resident and United States Congressman Robert Barnwell Rhett advocated resistance to the Tariff of 1842. Later, informal secession meetings earned the Milton Maxcy House on Craven Street the sobriquet "Secession House." In 1860 when South Carolina seceded, several with ties to Beaufort were among the signers. Hundreds volunteered for military service and the Beaufort

Beaufort Arsenal (713 Craven Street). *Courtesy of Library of Congress.*

Arsenal bustled with activity. The Beaufort Volunteer Artillery, with roots in the struggle for American independence, was one of the units from Beaufort that fought for the South.

The natural advantages of Port Royal Harbor were not lost on the United States government. Seeking a location for ship refueling and repair, in 1861 Commodore Samuel F. DuPont sailed his U.S. Naval fleet into Port Royal Harbor. General Thomas Sherman commanded the land forces. Within hours, guns from the ships silenced the Confederate forts on Hilton Head and Bay

Point. When news of the disaster reached Beaufort, residents hastily packed up and abandoned the city. Some left dinner on the table; most left their libraries, their furnishings and the life they had known. Many never returned to Beaufort. When the residents fled, slaves from surrounding plantations entered the abandoned city and celebrated their "freedom."

United States forces occupied the city in December 1861 and used the stately homes for various administrative functions and as hospitals. Fighting around Charleston and raids on the mainland created an increasing need for hospital space. After the raising of African American troops, several of the hospitals in Beaufort housed wounded and ill African American soldiers.

Fort Beauregard, Bay Point. Fort Beauregard was one of Beaufort's principal points of defense in 1861. *Courtesy of Library of Congress.*

Federal authorities seized and sent the Beaufort library north. Some wanted to sell the collection. Although that idea was rejected, the library was lost in 1865 when fire destroyed the building where it was housed in Washington, D.C. Final compensation for the loss arrived in 1950.

Federal occupation made the Beaufort area a haven for fleeing slaves. Hundreds enlisted in the First and Second South Carolina Regiments. Others performed support functions for the occupation forces. Thousands, though, needed food, shelter and education as they moved from slavery to freedom. The care of these former slaves led to the fascinating public-private cooperative known as the "Sea Island Experiment." Abolitionists from New England and the Middle Atlantic States moved to Beaufort and the Sea Islands and established schools for the former slaves. One of the oldest and most enduring was Penn School, now Penn Center, on St. Helena Island.

With Federal occupation, Beaufort also became a center of African American political aspirations. Robert Smalls, a native of Beaufort, gained overnight fame when he sailed a Confederate gunboat, *Planter*, out of Charleston harbor and past Confederate fortifications

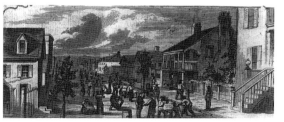

Street scene in Beaufort of contrabands (slaves who fled behind Union lines) loading stores. *Harper's Weekly. Courtesy of South Carolina Department of Archives and History.*

to the Federal fleet. A commissioned officer, the hero Smalls served throughout the war. With peace, he and his family returned to Beaufort. Smalls began a number of businesses and entered politics. He also purchased the Henry McKee home that had once belonged to the family who had owned his mother and him. Voters elected Smalls to the United States House of Representatives. He held a number

of important positions and his personal charisma and political savvy enabled him to survive the end of Reconstruction and the reestablishment of white rule in South Carolina. He remained a political force in Beaufort until his death. A monument on the grounds of Tabernacle Church honors Smalls and his contributions to the history of the state.

Plaque identifying the Henry McKee/ Robert Smalls House (511 Prince Street) as a National Historic Landmark. *Courtesy of Jacob Helsley.*

Like the Revolution, the Civil War brought dislocation and economic stresses to Beaufort. Northerners, altruistic and self-serving, came to Beaufort seeking areas of service or opportunities for financial gain. Union veterans, released from active service, chose to stay in Beaufort and build new lives. Former slaves sought ways to survive. They wanted their own schools, churches and land. With direct tax sales, some were successful in acquiring land and developed a successful black yeomanry, particularly on St. Helena Island . Others faced the trials of negotiating labor contracts with the government or with white landowners who attempted to return. Some returning whites successfully reclaimed their property. Others did not, and many did not try. During these years, agricultural production in the country fell.

In the 1870s phosphate mining along the coast of South Carolina spread to Beaufort County. Phosphates were a desirable source

of fertilizer. Mining brought employment for many of the county's residents and a boon for Bay Street merchants. Beaufort merchants also expanded into cotton ginning, cottonseed oil and other businesses related to that perennial cash crop. In 1883 the local economy also suffered when the navy yard left Port Royal for Charleston.

River shore showing the seawall. *Charles G. Luther, courtesy of William Benton.*

Just as many in Beaufort thought bright skies lay ahead, the Great Storm of 1893 slammed into the Sea Islands. The storm surge hit at high tide and devastated the low-lying islands. Water rose in the streets of Beaufort and two people died there. Thousands died on the islands. Clara Barton and the Red Cross came to minister to the survivors and help rebuild lives. Beaufort residents also organized relief efforts.

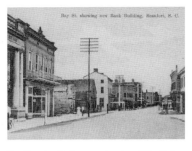

Bay Street with the new bank and the Saltus House on the left. The People's Bank burned in 1907. *Courtesy of Beaufort County Library.*

The worst of several fires struck Beaufort in 1907. The fire destroyed businesses and homes both north of Bay Street and in other parts of the town. The Great Depression of the 1930s found Beaufort struggling and cotton production decimated by infestation of the boll weevil. One bright spot was the steady growth of truck farming. Beaufort's temperate climate made the area an ideal spot for vegetable growing. At one time, Beaufort was dubbed the "Lettuce Capital." Growers not only produced lettuce, tomatoes and other crops for market, but some also opened their own canneries.

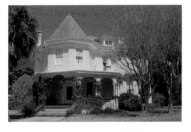

Emil E. Lengnick House (1411 North Street). Lengnick, whose father emigrated from Germany, built this distinctive house in the early 1900s. *Courtesy of Jacob Helsley.*

The outbreak of World War II heightened the military presence in Beaufort and began a decades-long growth in that sector of the local economy. The war and Congressman L. Mendel Rivers of the House Armed Services Committee made the Carolina Lowcountry desirable areas for military enterprises. The Marine Corps reactivated and expanded the air station. The Naval Hospital added beds and the government built Laurel Bay, a new housing development for military personnel.

By 1960, the military payroll was a major factor in the local economy. Today, its significance continues, but tourism dollars contribute more to the county's economy.

Change came slowly to Beaufort. The United States decided *Brown v. Board of Education* in 1954, but the first African American student did not enroll in Beaufort

700 block of Bay Street looking eastward. *Courtesy of Jacob Helsley.*

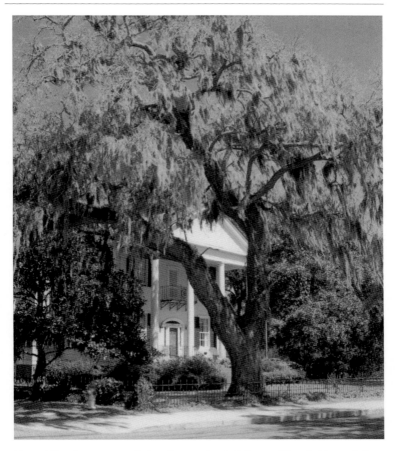

Many visitors have commented on the sun-dappled charm of Beaufort beneath her magnificent live oaks. *Courtesy of Jacob Helsley.*

High School until 1964. A truly integrated school system took several more years.

In the late 1960s the Republican Party found new life in Beaufort. After decades of Democratic allegiance in reaction to Republican Reconstruction, the party began fielding candidates and now controls political life in the county. In 1967 Joseph M. Wright became the first African American elected to County Council since Reconstruction and in 1974 Harriet Keyserling became the first woman elected to Beaufort County Council.

A major change came in 1956 when the James F. Byrnes Bridge to Hilton Head Island opened. The new bridge and Sea Pines Plantation ushered in a new era in the county. Beaufort—town and county—became havens for tourists and retirees. Local authors such as Pat Conroy penned enthralling tales of growing up in the Lowcountry, and movies such as *The Big Chill* (1983)

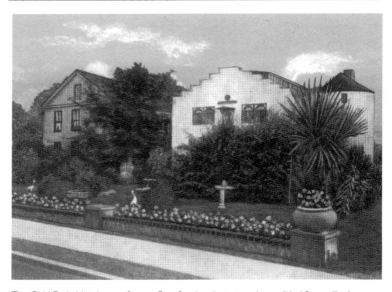

The Gold Eagle Hotel was a famous Beaufort inn that catered to political figures like James F. Byrnes, governor of South Carolina and Franklin Roosevelt's director of the office of war mobilization, and movie stars like Clark Gable. It once stood on the river at the corner of New and Bay Streets. The Gold Eagle was torn down in the late 1960s. *Curt Teich Co., courtesy of William Benton.*

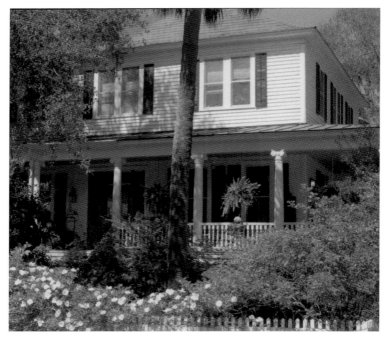

Beaufort in the springtime—no fairer place. Corner of North and Wilmington Streets. *Courtesy of Jacob Helsley.*

and *The Great Santini* (1979) popularized the built heritage of the city. As a result, more movie producers chose to film in Beaufort. Among the better-known movies filmed in Beaufort or in the county were *Forrest Gump, The Prince of Tides* and *G.I. Jane.*

As its fame spread, Beaufort Mayor Henry Chambers launched a drive to construct a riverfront park. More newcomers chose to buy the handsome houses that were testaments to antebellum living, and the character of the city changed.

Yet, despite its status as a Landmark District, Beaufort's historic district is under siege. To qualify as a Landmark District, over 50 percent of the structures in the area must have retained their architectural integrity and be over fifty years old. According to a recent survey, Beaufort is losing ground. Protecting the unique charm of Beaufort is an ongoing and challenging task.

Modern Beaufort is thriving. Bay Street bustles with shops and restaurants. Quiet, sleepy Beaufort is no more. Yet, the shadows of the men and women—European, African American and Native American—who gave their lives to create this uniquely beautiful place are ever present.

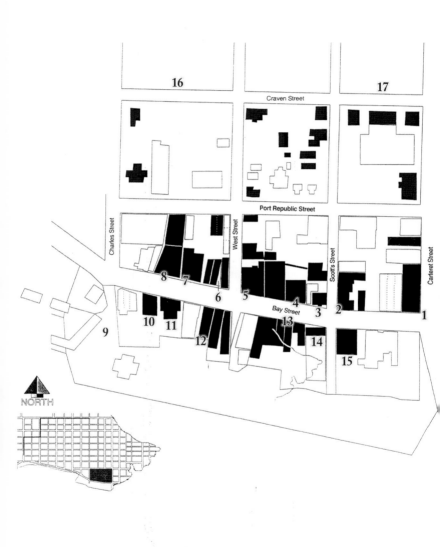

16

17

Craven Street

Port Republic Street

Charles Street

West Street

Scott's Street

Carteret Street

8 7

6

5

4

3

2

1

Bay Street

10 11

13

9

12

14

15

NORTH

Downtown Commercial District

(Bay Street and environs between Charles
and Carteret Streets)

Bay Street is the heart of Beaufort's commercial district. It is bounded by Charles Street to the west and Carteret Street to the east. To the north is Craven Street and to the south, the Beaufort River. Bay Street has been the commercial heart of the city since its beginning. The first lots claimed in the city were those fronting the river. Merchants, planters and other entrepreneurs developed the lots north of Bay Street. They built homes and businesses that faced the river. In Beaufort, structures on the river normally face south toward the water. Residential areas to the east, north and west surround this three-block-long commercial core.

In 1715 a ship moored at a bayside dock saved residents when the Yemassees attacked island residents. This escape is one of the few references to the earliest years of Beaufort's life. Following the Yemassee War, the new town fared poorly. The government offered incentives to attract new settlers and gradually the town took shape. The first residents gravitated to the three blocks along the Bay between Charles and Carteret Streets.

Before the Revolutionary War, Beaufort's commercial district grew slowly. But as indigo and rice production increased, so did business along the river. Merchants such as Charles Purry, Francis Stuart and Daniel DeSaussure operated dry goods and similar stores along Bay Street. Purry and Stuart's establishments were located in the block between West and Scott Streets on the north side of Bay Street.

Charles Purry was the son of Jean Pierre Purry, a native of Neufchatel, Switzerland, whose dream of a Swiss settlement in South Carolina culminated in the founding of Purrysburg on the Savannah River in 1734. The settlement did not succeed and Jean's son Charles became a highly successful Bay Street merchant. His mercantile career ended in 1754 when he was poisoned by one of his slaves.

With the introduction of indigo planting in the 1750s and the end of the French and Indian War in 1763, Beaufort prospered. The planters had a new cash crop and the decades-old fear of Spanish raids ended. Also, rice cultivation spread in the district. Population grew. Trade with Savannah flourished. Some firms operated stores in both

Beaufort and Savannah. The value of land and of slaves increased. On the eve of the American Revolution, Beaufort was a thriving town. In addition to cash crops and naval stores, shipbuilding was an important business and the harbor bustled.

Between 1763 and the Revolutionary War, the Port Royal Sea Islands became the center for shipbuilding in the Southern colonies. By the early 1770s, even naval men in Great Britain recognized the value of Beaufort's majestic live oak for ship construction. Some scholars contend that the live oak can last forty to fifty years as ship timber. Many of the vessels built in and near Beaufort were for the coastal trade. However, as early as 1740, area shipyards were producing oceangoing vessels as well. Between 1763 and 1774, ten shipbuilders operating in the Beaufort area built thirty vessels. James Black who operated a shipyard on the Point, built at least three of these: the *Atlantic*, the *Georgetown* and the *Ashley Cooper*.

Much of the trade in Beaufort was the coastal trade that traveled the waterways between Charles Town and Savannah. However, some ships traded directly with the West Indies and a few with England.

Early businesses included wharves, warehouses, taverns, hotels and retail shops. The production of indigo and rice spurred economic growth in Beaufort. As a result, while the port developed slowly, by 1775 it rivaled Charles Town in trade. Merchants and planters exported rice and indigo and occasionally, a slave ship anchored with its cargo for sale.

The Revolutionary War changed life in Beaufort. British forces under Augustine Prevost occupied the town in 1779. The coming of independence divided residents. Some, like the Huguenot merchant Daniel DeSaussure, favored the Patriot cause. Others, such as Peter Lavein, Zephaniah Kingsley, Henry Stuart (brother and heir of Francis Stuart) and William Bellinger Kelsal remained loyal to the King. Lavein, the half-brother of Alexander Hamilton, had moved to Beaufort from Saint Croix in 1766. In a double irony, John Kean, his apprentice, became the first United States Congressman from Beaufort District. Yet, Lavein persisted in his loyalty to the Crown.

Loyalist merchants thrived during the British occupation, but the British imprisoned DeSaussure and confiscated his property. However, the new South Carolina state government confiscated in turn the property of several of these Loyalist merchants. So, with the Patriot victory, many left the colony and their homes and businesses. DeSaussure was able to repurchase his lost property, but at an inflated price. William Bellinger Kelsal, the Loyalist

Streetscape, 800 block Bay Street looking northwest. *Courtesy of State Historic Preservation Office, South Carolina Department of Archives and History.*

merchant and planter, had married DeSaussure's sister. The state did not confiscate Kelsal's property, but the Beaufort District Grand Jury called for an investigation into his wartime activities. Kelsal had served in the Tory Militia. As a result, Kelsal and his family left South Carolina in 1788.

Recovery, though, was difficult. The Revolutionary War devastated the Port Royal area. British raids had burned the Parish Church of Prince William's Parish (Sheldon), taken horses and other livestock and destroyed crops and homes. Reportedly, Banastre Tarleton outfitted his dragoons with Beaufort District horses. Rice fields were damaged and dykes had to be rebuilt. With the loss of the British subsidy, growing indigo was no longer profitable. Small-scale production, nevertheless, continued into the nineteenth century.

Change and a new day came with a new cash crop. The coming of sea-island cotton altered the agricultural and commercial landscape of Beaufort. In 1790 William Elliott, on his Myrtle Bank Plantation on Hilton Head, was the first to cultivate sea-island cotton in Beaufort District. Cotton made the Elliotts, Barnwells and other Beaufort planters wealthy and politically influential.

Most early commercial development occurred along the north side of Bay Street. Development on the south or river side of Bay Street was late in coming. While the colony granted the first low water lots for land on the south side of Bay Street in 1763, it took the revitalization of Bay Street in the 1790s to spur development there. Merchants such as John Rhodes, John Bold and Francis Saltus wanted to develop their property there. At that time, Saltus owned one of the low water lots that had been granted earlier to Francis Stuart.

In time, in addition to residential development, stores, warehouses, docks, wharves, landings and other maritime enterprises filled in the vacant areas south of Bay Street. This expansion of commercial and residential construction south of the street produced controversy. Many lamented the lack of ready access to the river, and the town feared the blocking of its north/south streets. In an area that relied heavily on its waterways, control of docks and wharves was crucial for economic survival.

In 1796 the South Carolina General Assembly passed act no. 1703 that specifically stated that:

> *The streets in the said town, which run northwardly and southwardly, and which extend to Bay Street...shall be open... to the river...and...at all times accessible to all persons.*

This act stopped construction south of Bay Street. Yet, owners such as Saltus appealed to the General Assembly. This time, the South Carolina General Assembly permitted the owners who had not been compensated for their riverfront property to develop their property south of Bay Street.

Construction on both sides of the street reflected mixed commercial and residential use. While some Beaufort residents built freestanding homes along Bay Street, others occupied residential space above street level commercial buildings. The street's location and name reflects the seaward focus of these early residents. Most early properties along Bay Street faced the river.

With more disposable income, Bay Street businessmen diversified to offer more luxury goods and complained then as now about the competition of Savannah and Charleston. Many planters found it less expensive to deliver their crops to a major exporting port such as Charleston and Savannah and do their shopping there. Still, professional men hung out their shingles on Bay Street and taverns thrived. Beaufort in the 1790s was a boisterous place. Planters practiced heavy drinking and card playing.

The antebellum period brought more growth. The cotton planters built elegant town homes in Beaufort. By the 1830s and 1840s, residents were building houses south of Bay Street again. Michael O'Connor, an Irish immigrant, and Abraham Cockcroft built imposing homes on the bay. O'Connor came to Beaufort in 1822 and was instrumental in building a Catholic church in Beaufort.

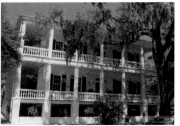

Thomas Rhett House, ca. 1820 (1009 Craven Street). Thomas Rhett (1794–1860) was one of the Smith brothers who legally changed their last names to Rhett. His brothers included Edmund Rhett and Robert Barnwell Rhett. *Courtesy of Jacob Helsley.*

The 1850s saw a domestic and governmental building boom. Residents rebuilt the Arsenal and erected Beaufort College. Planters such as Joseph Johnson constructed elegant testimonies to their financial success. In 1859 Franklin Talbird built a wharf at the foot of Charles Street and Captain John Murray erected another wharf on an adjoining lot.

At the time of the Civil War, Bay Street boasted carpenters, bakeries, a carriage and cartmaker, blacksmiths, a French vinedresser and a music teacher. Occupying troops and support staff occupied many of the buildings, but in time entrepreneurs like George W. Woodman moved in to provide home cooking, rooms, merchandise and entertainment for troops and visitors. Still, Mrs. Augusta French who accompanied her husband, the Reverend Mansfield French, to Beaufort in 1862 commented on the "utter desolation" of the city's streets. During the early months of the Union occupation, there was a curfew in effect and endless drills and reconnaissance missions for the troops. The troops were bored and had few social outlets.

Military and other governmental agencies occupied many of the buildings on Bay Street. Stores such as Douglas & Co. sold military

and naval goods. Maps, stationery and books were available in the post office building and restaurants such as the Lincoln House catered to hungry visitors and residents. The Magnolia House was one of the hotels available as business flourished along Bay Street.

With the end of the war, commercial activity continued, but the players were different. Beaufort's population was more diverse, as more residents had been born outside of South Carolina. Northerners such as George Waterhouse became successful businessmen. Waterhouse's cotton gin and warehouse stood near the river opposite the intersection of Charles and Bay Streets. Immigrants and Union veterans like Niels Christensen (a native of Denmark) saw economic potential in the recovering city. Christensen invested in commercial enterprises and real estate. The Austrian-born Moritz Pollitzer had a cotton mill on the north side of Bay Street. By 1870 Bay Street had a pronounced international flavor. As a seaport, Beaufort has always been more cosmopolitan in population than was typical of South Carolina's inland counties.

700 block Bay streetscape looking eastward. *Courtesy of Jacob Helsley.*

By 1880 Bay Street had a post office, grocery stores, taverns, a cigar manufacturing plant and a variety of retail establishments. In 1882 the city directory listed forty-three stores. These establishments offered Beaufort residents dry goods, groceries and hardware. The riverfront sported steam gins, sawmills and plants that processed phosphates into fertilizer.

The picture changed dramatically with the Great Storm of 1893. The storm surge hit at high tide and waves in the city were twenty feet high. The waves destroyed the seawall, smashed docks and wharves along the Bay and severely damaged several warehouses between Bay Street and the river. By 1894 owners had rebuilt or repaired the cotton gins and warehouses along the river. In 1899 R.R. Legare operated a sawmill south of Bay Street—evidence of the booming timber industry—as Beaufort once again capitalized on its natural resources. Naval stores had been an economic engine for the development of Colonial Beaufort.

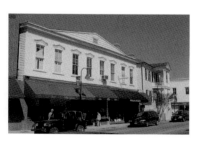

Keyserling Building, ca. 1885 (807–813 Bay Street). The Keyserling Building is one of several Victorian commercial buildings in Beaufort. *Courtesy of Jacob Helsley.*

With the dawn of the new century, a Coca-Cola bottling plant joined the warehouses and

TOUR I

mills of Beaufort's waterfront. Bay Street was also home to the *Beaufort Gazette*'s office, an ice works and the Bank of Beaufort. Doctors, lawyers and insurance agents also had offices along the street.

TOUR I

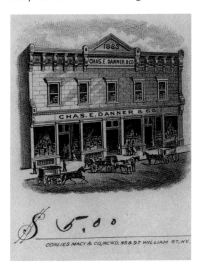

Charles E. Danner & Co., 1903, 700 block of Bay Street. *Courtesy of Dr. George A. Jones.*

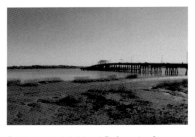

Bridge to Lady's Island. Before the first Lady's Island bridge in 1927, the ferry that connected Beaufort with Lady's and St. Helena Islands ran from the foot of Carteret Street. *Courtesy of Jacob Helsley.*

Yet again disaster struck the commercial district in January 1907. Two boys smoking in a stable at the corner of Bay and Carteret Streets sparked a conflagration that threatened to destroy the heart of Beaufort. The fire spread west and destroyed Scheper's grocery, the People's Bank, Ah Li's Laundry, restaurants, the dispensary, Christensen's Hardware and other stores. As a result, many structures on Bay Street now date back only to the early twentieth century.

By 1912 the city's streets were "shell" paved and sported electric lights. A large hardware store stood on the corner of Carteret and Bay Streets. Other fires in the 1920s continued to redesign the commercial landscape.

With the growth of truck farming on the Sea Islands in the 1920s, Beaufort was known as the "Lettuce City." The need to get the crops to market led to improvements in transportation. As a result, in 1925 a truss bridge first spanned the river connecting Port Royal and Lady's Island. The location of the bridge at the foot of Carteret Street was near the former landing for the Lady's Island ferry.

Today, the old businesses are gone. New enterprises line Bay Street's busy three blocks. But the buildings that survived fire and storm still harbor the shops and restaurants of today.

1. Fordham's Market (701 Bay Street), ca. 1907.

The corner of Bay and Carteret Streets was once, according to some sources, the site of an eighteenth century commercial compound owned by Francis Stuart. Francis Stuart & Co. opened in 1762.

Stuart was a merchant, planter and shipbuilder. His establishment included a house, store, kitchen, dairy and other outbuildings. Stuart's investment included commercial structures on both sides of Bay Street, as he owned several low water lots. Francis Stuart's brother, Colonel John Stuart, was a Colonial Indian agent. Together, they owned one of the most prosperous indigo plantations in pre-Revolutionary South Carolina. Francis Stuart married the granddaughter of Colonel John "Tuscarora Jack" Barnwell, hero of the Tuscarora War in North Carolina and a leading light in the development of Beaufort. After Stuart's death in 1766, his brother and heir, Henry Stuart, attempted to carry on the business. The Revolutionary War intervened and Stuart sided with the British, lost his investment and left South Carolina for Florida and eventually died in England.

2. DeSaussure Store (715 Bay Street), ca. 1908.

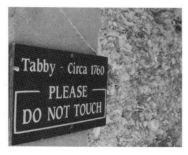

This exposed tabby wall dates from the mid-eighteenth century. Incorporated in a much later structure, these tabby walls are probably all that remains of Daniel DeSaussure's dry goods store. In 1774 DeSaussure bought the property from his partner John Delagaye after the latter returned to France. DeSaussure was a leading Patriot of Beaufort District and during the American Revolution, the British confiscated his property. After the British left South Carolina, DeSaussure returned to Beaufort and reopened his store on Bay Street. *Courtesy of Jacob Helsley.*

The corner of Bay and Scott Streets was the location of Daniel DeSaussure's store. DeSaussure (1735–1798), the son of a Huguenot planter at Coosawhatchie, traded in rice and indigo. He moved to Beaufort in 1768 and employed John Mark Verdier, the son of another Huguenot, to manage his store. DeSaussure formed connections with Charleston merchants that survived the Revolutionary War. A Patriot, DeSaussure faced great hardships during the Revolution. When the British occupied Beaufort in 1779, they imprisoned him in Saint Augustine and confiscated his valuable commercial complex on Bay Street. Loyalist Zephaniah Kingsley purchased the DeSaussure property from the British. The site included a house and store on Bay Street, and a number of tabby outbuildings including a kitchen, smokehouse and stable. The State of South Carolina confiscated Kingsley's property and banished him from the state. DeSaussure, in partnership with John Mark Verdier, George Smith and Josiah Smith, eventually reclaimed his property. Nothing survives of his eighteenth-century buildings except the tabby walls incorporated in a later structure.

3. John Mark Verdier House (801 Bay Street), ca. 1801.

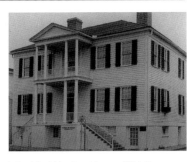

John Mark Verdier House (801 Bay Street), ca. 1801. John Mark Verdier was a Beaufort merchant who suffered through the vicissitudes of post-Revolutionary War recovery, prospered during the cotton inspired recovery and still died a poor man. *Courtesy of State Historic Preservation Office, South Carolina Department of Archives and History.*

Verdier was the son of Andrew Verdier, a Huguenot shopkeeper in Okatie. Daniel DeSaussure gave John Mark Verdier his start on Bay Street when he hired him to operate his store. After the Revolution, Verdier became one of the most successful merchants in Beaufort. In 1783 he acquired the DeSaussure property and operated the store for a Charleston firm of which DeSaussure was a member. Around 1800 he tore down the old house on the site and built this one across the street from the Saltus house.

On March 18, 1825, the Marquis de Lafayette and his son visited Beaufort. Lafayette was delayed in Savannah and arrived late in the evening. Yet Beaufort dignitaries and the members of the Beaufort Volunteer Artillery met his ship and accompanied him to the Verdier House. Despite his great success at times, Verdier, like many businessmen, weathered a number of financial challenges, faced debtor's prison and, in the end, died a poor man in Charleston.

Union forces used the house during the Civil War. After the war, a variety of small businesses, such as a typing service, a barbershop, law offices and even a market, made their homes in the historic structure. In 1940 possession of the house passed to a committee of concerned citizens formed to preserve it. Later, in 1967 this committee organized the Historic Beaufort Foundation. The Historic Beaufort Foundation acquired the property in 1968 and restored the house. The John Mark Verdier House is a vital member of Beaufort's historic district.

4. Keyserling Building (807–813 Bay Street), ca. 1885.

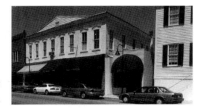

Keyserling Building, ca. 1885 (807–813 Bay Street). *Courtesy of State Historic Preservation Office, South Carolina Department of Archives and History.*

The Keyserling Building is a fine example of Victorian commercial design. Behind this stylish late nineteenth-century edifice is a circa 1800 tabby wall that bears evidence of an older past. The

wall may represent a garden or compound wall, or the remnant of an outbuilding from one of the commercial compounds that included domestic and business structures built by eighteenth- and early nineteenth-century merchants.

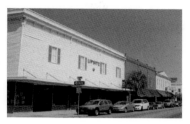

800 block, Bay Street looking eastward with Lipsitz Store and Keyserling Building on the left. *Courtesy of Jacob Helsley.*

5. *Lipsitz Building (825 Bay Street), ca. 1880.*

The Lipsitz Building is a Victorian-style commercial building. Moses Lipsitz, a native of Russia who immigrated to the United States in 1890, renovated his mercantile store on this site in 1922.

TOUR 1

6. *Chisholm Building (905–907 Bay Street), ca. 1770.*

The Chisholm Building is one of the few identified pre-Revolutionary structures that stand in Beaufort. While commercial activity flourished in Beaufort on the eve of the American Revolution, there are few documented structures in the city that date from that period. A number of individuals named Chisholm were active in Colonial South Carolina. One, a St. Helena planter named Thomas Chisholm, bought a half-interest in a schooner named *Endeavor* in 1747.

7. *Schein Building (915 Bay Street), ca. 1898.*

In 1920 David R. Schein, a native of Prussia, was a forty-four-year-old retail merchant. A fire in 1928 destroyed the original building, but Schein rebuilt and updated his store.

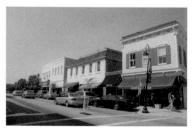

900 block, Bay Street looking westward. *Courtesy of Jacob Helsley.*

8. *Edwards Building (917 Bay Street).*

The Edwards Department Store opened in 1954. Later, the building was adapted as a retail market.

9. Henry Chambers Waterfront Park.

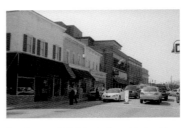

The city broke ground for the park in 1975. The construction of this park was a dream of then-Beaufort Mayor Henry Chambers. Constructed primarily with federal grants, the park replaced the old wharves and warehouses that characterized over 250 years of the city's commercial life. While the

Bay Street, 900 block riverside looking westward. Old Customs House and bank to the far right. *Courtesy of Jacob Helsley.*

park provided entertainment and vistas of the river, its construction forever separated the commercial heart of the city from the waterway upon which it had historically depended.

10. Beaufort Bank (928 Bay Street), ca. 1916.

This was the site of the old post office before the erection of the bank building. This structure has served a number of functions, including a movie theater and a restaurant.

11. Abraham Cockcroft House (920 Bay Street), ca. 1857.

During the Civil War, the Cockcroft building housed military offices. Later, it became the customs house.

12. Luther's Pharmacy (910 Bay Street), ca. 1884.

By 1900 Charles Luther, a native of New York, appeared on the census as a druggist. Ten years later the forty-two-year-old Luther was listed as a "retail merchant." Luther's Pharmacy was a fixture on Bay Street for decades. Luther also published a series of Beaufort postcards. Today the building houses a restaurant.

Luther's from the Bay (910 Bay Street). The commercial buildings south of Bay Street were oriented toward the river. The riverfront park now lies between these buildings and the wharves, warehouses and docks that once fed Beaufort's commerce. *Courtesy of Jacob Helsley.*

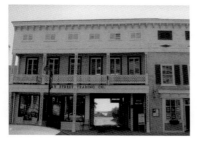

John Cross Tavern (Saltus Store). *Courtesy of Jacob Helsley.*

13. John Cross Tavern— Captain Francis Saltus Store (812 Bay Street), 1796.

At one point, this was the site of John Cross Tavern. In his tavern, Cross is supposed to have entertained both John Wesley, the father of Methodism, and Parson Weems who died in Beaufort. Weems's biography of George Washington popularized the cherry tree story. During the Civil War, G.W. Woodman, a native of Maine, operated a store in this building. The store was originally part of the Saltus compound on the south side of Bay Street. In addition to the house and store, there were probably other outbuildings such as stables, kitchen and smokehouse.

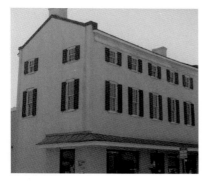

Francis Saltus House, ca. 1796 (802 Bay Street). Captain Francis Saltus was a mariner who built this house on land that had been granted to Francis Stuart in 1763. *Courtesy of Jacob Helsley.* Danner Store, 700 block of Bay Street.

14. Saltus House (802 Bay Street), ca. 1796.

Captain Francis Saltus built this three-story tabby house on one of the low water lots that had been granted to Francis Stuart in 1763. A warehouse may have also stood on the site. Saltus, a well-known eighteenth-century mariner, overcame local opposition to development south of Bay Street and built his home and store in a compound on the south side of Bay Street.

Saltus had a wharf between his house and his store. In the nineteenth century, it was the usual landing for steamships visiting Beaufort. Steamers such as the *Clivedon* and *Pilot Boy* plied the waters between Savannah, Charleston and Beaufort.

Charles E. Danner & Co., a mercantile establishment, opened in 1883. *Courtesy of Jacob Helsley.*

15. *Charles E. Danner & Co. (720–724 Bay Street), ca. 1910.*

In 1900 Charles Danner listed his occupation as merchant. An active member of the Baptist Church of Beaufort, Danner served thirty-two years as a deacon and twenty-four years as superintendent of the Sunday school.

16. *Tabernacle Baptist Church (911 Craven Street).*

At least by 1830 and perhaps earlier, the Baptist Church of Beaufort built Tabernacle as a meetinghouse. They used the structure for lectures and small group studies. During the Civil War, after Union forces converted the Baptist Church of Beaufort into a hospital, African American Baptists began to worship at Tabernacle. In 1863, they constituted a new church. The Baptist Church of Beaufort conveyed the property to the Tabernacle Baptist Church in 1867. Tabernacle deacons who closed the transaction were Renty Field, June Harris, Cornelius Singleton and James Snipes. The church added a bell tower in 1873. Tabernacle suffered great damage from the Hurricane of 1893. As a result, the church was either rebuilt or a new building was constructed. The cornerstone bears the date 1894. United States Congressman Robert Smalls was a member and is buried in the churchyard.

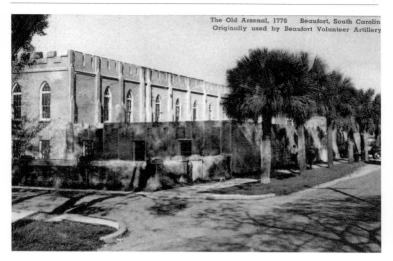

The Old Arsenal, 1776 Beaufort, South Carolin
Originally used by Beaufort Volunteer Artillery

The Arsenal (713 Craven Street), home of the Beaufort Volunteer Artillery. *Luther's Pharmacy, courtesy of William Benton.*

17. The Arsenal (713 Craven Street).

Thomas Talbird, a noted Beaufort builder, constructed the original Arsenal on the site of the first courthouse. Problems plagued the building. Rebuilt in 1852, the Arsenal was home to the Beaufort Volunteer Artillery, a military unit that traced its history to the American Revolution. After the battle of Port Royal, Union troops occupied the Arsenal during the Civil War. In 2001 the Historic Beaufort Foundation acquired the building. The Arsenal houses the Beaufort Museum. The museum's collection documents the long history of Beaufort County.

Old Point

(EAST OF CARTERET)

The Old Point, or just the Point, is a historic neighborhood that lies east of the town's center. The Point is a promontory that has Carteret Street as its western boundary and the Beaufort River as its northern, eastern and southern boundaries.

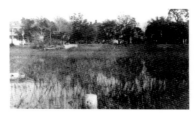

The Point from the river, 1925. *Courtesy of South Caroliniana Library.*

Once known as Black's Point, this area for many years lay outside the original bounds of the city. Yet commercial and residential development on the Point began in the early years of Beaufort's existence. Few traces of these pre-Revolutionary structures survive. The Thomas Hepworth House (214 New Street), circa 1760, and the William Johnson House (414 New Street), circa 1776, are two possibilities.

On the eve of the American Revolution, James Black operated a prosperous shipbuilding enterprise on the Point. Black had acquired his property on the Point from Thomas Middleton. Most shipbuilding in the colonial era was itinerant, as journeymen ships' carpenters and other artisans set up temporary camps along Lowcountry waterways. Timber and access to deep water were essential for shipbuilding. Early shipbuilding sites in Beaufort District included Spanish Point near Beaufort and locations on Lady's, Hilton Head and Daufuskie Islands.

Black's shipyard was different—it was the only permanent

Hepworth House (214 New Street). *Courtesy of Library of Congress.*

shipbuilding enterprise in the region. Among the ships built by James Black were the *Ashley Cooper* and the *Georgetown*. Black's shipyard may have stood on the block bounded by Pinckney, Federal and Hamilton Streets with the river as its southern boundary. Lowcountry live oak was in high demand and the Carolina Lowcountry furnished ships

for an international trade. The Revolution changed that picture. Black died during the war, and shipbuilding in the Beaufort area slowly disappeared.

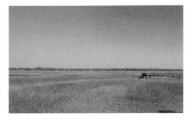

Looking toward Lady's Island from the Point. *Courtesy of Jacob Helsley.*

At his death in 1770, Black probably owned much of the Point. His house and boatyard likely sat near the mouth of a tidal creek that ran through the area. His property passed to his heirs and was subdivided into smaller tracts.

At the turn of the nineteenth century, a number of houses stood on the Point. Properties that date from 1783 (the date of the treaty that ended the American Revolution) to 1800 include the Chaplin House (712 New Street), the Hext-Sams House (207 Hancock) and the Elizabeth Barnwell Gough House (705 Washington Street).

Seeing the development, Beaufort's intendant (mayor) and wardens (city council), pleading "urgent necessity," petitioned to extend the town's boundary to include Black's Point. In 1809 the South Carolina General Assembly enacted legislation that allowed the town to annex the area and name and lay out streets. As a result, the newly laid out streets vary slightly from the original grid of the town. Most of the streets bear the names of Revolutionary War figures, such as Hancock, named for John Hancock, president of the Continental Congress; Laurens for Henry Laurens, South Carolinian whom the British imprisoned in the Tower of London; and Hamilton for Alexander Hamilton, aide to General George Washington and architect of the United States economy.

During the 1850s and early 1860s the town had a tabby seawall constructed along the banks of the river. This original wall required repair later, and Beaufort residents built other walls in the late nineteenth and early twentieth centuries. However, one of the best-preserved examples of this early effort is the seawall east of Carteret Street.

Tidalholm (1 Laurens Street), built by Edgar Fripp circa 1853, sits at the tip of the Point. Tidalholm is one of the houses that rings the Green, a private green space. The Green is a city block bounded by Short, Pinckney, Laurens and King Streets. This grassy area is a unique open space in the city of Beaufort. Through the years, children have played and dreamed there.

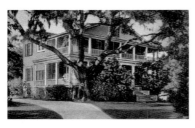

Tidalholm, the Edgar Fripp House (1 Laurens Street). *Luther's Pharmacy, courtesy of William Benton.*

By the 1880s, Niels Christensen operated a planing (lumber) mill on the Point. The mill sat on the

river in a block bounded by Port Republic, East and Craven Streets. Sanborn maps show the mill in operation into the early twentieth century. With this exception, however, by the twentieth century, occupancy of the Point was primarily residential. Today, the Point features premier examples of the Beaufort style of architecture and provides an intimate opportunity to experience the look and feel of antebellum Beaufort. Here, the visitor can sense why historians laud the intellectual and artistic achievements of Beaufort's antebellum elite.

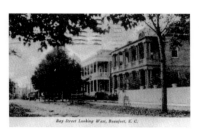

Bay Street looking west with the William Joseph Thomas and John N. Wallace houses on the right. According to Charlotte Forten, "The houses [in Beaufort] are large and quite handsome...with verandahs around them, and beautiful trees." *Crescent Drug Company, courtesy of William Benton.*

1. *Wallace House (611 Bay Street), 1909.*

This home, built by John N. Wallace, replaced the Fuller house, which burned in the great fire of 1907. Wallace, a native of Ohio, was a dry goods merchant in Beaufort. In 1880 he was single and living on Port Republic Street.

John Gordon, Bay Street merchant, built the original house circa 1770. At the time of the Civil War, Thomas Fuller was the owner. According to the 1860 census, there was a Thomas Fuller, age seventy-three years, living in Beaufort. This Fuller was a physician and planter and owned real estate, including three plantations, valued at $50,000 and personal property (including 220 slaves) valued at $150,000. Fuller had a medical degree from the University of Pennsylvania and served as a trustee of Beaufort College.

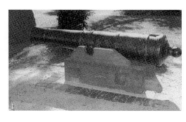

Cannon in park with memorial to Brigadier General Stephen Elliott (Carteret at Bay Streets). The plaque states that the memorial was erected opposite the house where the Stephen Elliott Chapter of the United Daughters of the Confederacy was organized. *Courtesy of Jacob Helsley.*

2. *William Joseph Thomas House (607 Bay Street).*

At the time of the Civil War, this was the site of the home of General Stephen Elliott (1832–1866). In 1860 Stephen Elliott Jr. was a twenty-nine-year-old planter with real estate valued at $15,000 and personal property (including slaves) worth $35,000. Elliott, the son of Bishop Stephen Elliott, was one of the ablest military men born in antebellum Beaufort.

TOUR II

The house was destroyed by fire in 1907 and rebuilt by William Joseph Thomas in 1909. Thomas, a native of South Carolina, was a lawyer.

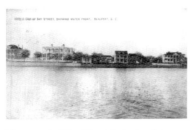

Upper end of Bay Street featuring the Lewis Reeve Sams House on the left. *W.E. Bristol, courtesy of William Benton.*

3. *Lewis Reeve Sams House (601 Bay Street).*

Lewis Reeve Sams (1784–1856), a Datha Island planter, built this house circa 1852. According to the direct tax records, the Reverend Thomas Fuller Sams owned the house in 1862. In 1860, Thomas F. Sams was an eighteen-year-old student at Princeton College in New Jersey.

While Sams retained ownership of the property through the Civil War, he mortgaged the property twice—first to George W. Woodman and later to George Waterhouse. In 1968 Waterhouse acquired the property outright. Waterhouse, a transplant from Maine, was a grocer in 1880. By 1900 his widow Harriet, a native of New York, lived in the house. In 1910, she and two daughters, all listed on the census as having their "own income," occupied the house. The younger George Waterhouse, who operated the cotton gin, was thirty years old in 1910 and lived on New Street. George and his sisters were all born in South Carolina. Allegedly, the Sams House survived the 1907 fire because the employees of Waterhouse's cotton gin organized a water brigade and extinguished the blaze.

4. *Thomas Hepworth House (214 New Street).*

One of the few pre-Revolutionary War structures in Beaufort, the Hepworth House dates from circa 1760. On August 10, 1717, Thomas Hepworth received a land grant for one town lot in Beaufort. Hepworth also owned property in Craven, Berkeley and Colleton Counties and in the town of Charles Town. In 1724 Thomas Hepworth was chief justice of South Carolina in the Court of Common Pleas (civil court). In 1740–41, Hepworth conveyed part of a lot in Beaufort to Thomas Burton. Burton subsequently acquired other property in Beaufort. In the late nineteenth century, owners altered the New Street house.

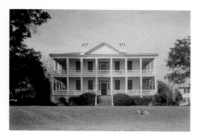

George Moss Stoney House (500 Port Republic Street). *Courtesy of Library of Congress.*

5. *George Moss Stoney House (500 Port Republic Street).*

This house was built circa 1830 by Dr. George Moss Stoney for his wife Sarah Barnwell Stoney. Stoney, a planter and physician, was fifty-five years old in 1850 and possessed real estate valued at $6,000. By 1860 he had died and Sarah B. Stoney, age fifty-seven, was a planter with real property valued at $6,000 and personal property worth $12,000.

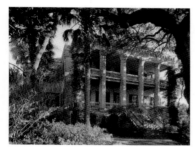

Joseph Johnson House, "The Castle" (411 Craven Street). *Courtesy of Library of Congress.*

6. *Joseph Johnson House, "The Castle" (411 Craven Street).*

This impressive house sits on a canal in resplendent isolation. Dr. Joseph Fickling Johnson, the brother of John Archibald Johnson, built this house between 1859 and 1861. In 1860 the forty-eight-year-old Johnson owned real property, including a plantation on Lady's Island, valued at $25,000 and personal property, including slaves, worth $15,000. During the Civil War, Union troops used the house as a hospital. After the war, Johnson paid the taxes and regained his property.

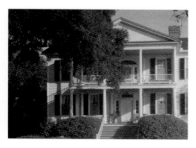

William Fripp House, "Tidewater" (302 Federal Street). Tidewater was the town home of "Good Billy" Fripp, noted for his benevolence. *Courtesy of Library of Congress.*

7. *William Fripp House, "Tidewater" (302 Federal Street).*

William Fripp (1788–1861) built this town house between 1825 and 1830. The house faced a canal that once provided access to the property. Fripp, known as "Good Billy" Fripp for his benevolences, owned Pine Grove Plantation on St. Helena

TOUR II

Island and 325 slaves. Fripp was a justice of the peace, a Free School commissioner, a trustee of Beaufort College and a deacon of the Baptist church on St. Helena Island (Brick Church). In 1867 Tidewater was sold for taxes.

8. *James Robert Verdier House, "Marshlands" (501 Pinckney Street), ca. 1814.*

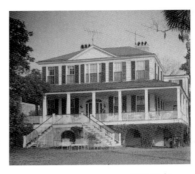

Verdier developed a successful treatment for yellow fever. Yellow fever was a scourge of the Lowcountry. An outbreak in 1817 closed Beaufort College. In 1850, Verdier was a fifty-eight-year-old physician and planter who held real estate valued at $6,000. At the outbreak of the

James Robert Verdier House (501 Pinckney Street). Of French Huguenot descent, the Verdiers were successful businessmen and planters. *Courtesy of Library of Congress.*

Civil War, William Chisholm owned the property. Francis Griswold used Marshlands as the setting for his post-Civil War romance, *A Sea Island Lady.*

9. *The Green.*

A private open space that occupies the block bounded by Short, Pinckney, Laurens and King Streets. This park contributes to the special character of the Point.

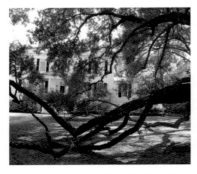

Paul Hamilton House, "The Oaks," north (rear) elevation (100 Laurens Street). Colonel Paul Hamilton built this house ca. 1844. *Courtesy of Jacob Helsley.*

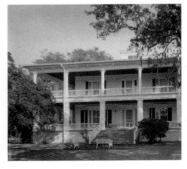

Paul Hamilton House, "The Oaks" (100 Laurens Street). *Courtesy of Library of Congress.*

10. *Paul Hamilton House, "The Oaks" (100 Laurens Street), ca. 1855.*

Colonel Paul Hamilton built this house during the great antebellum building boom in Beaufort. Hamilton's grandfather, also named Paul Hamilton, served as secretary of the navy under President James Madison. Union forces utilized the house as a hospital during the Civil War.

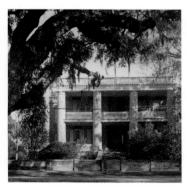

Berners Barnwell Sams House #2 (201 Laurens Street). *Courtesy of Library of Congress.*

11. *Berners Barnwell Sams House #2 (201 Laurens Street), ca. 1852.*

Sams, a physician and planter, with his brother Lewis Reeve Sams owned plantations on Datha and Lady's Islands. The house's outbuildings, or dependencies, survive. At one time, they would have housed the servants, the kitchen and other domestic establishments. During the Civil War, the house served as a hospital. After the war, William Wilson bought it at a direct tax sale.

Tour II

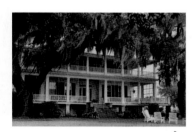

Edgar Fripp House, Tidalholm, ca. 1853, (1 Laurens Street). Edgar Fripp was a proud man who, according to family manuscripts, on occasion made his slaves work through the night. A number of movies, including *The Great Santini* and *The Big Chill*, featured this house. *Courtesy of State Historic Preservation Office, South Carolina Department of Archives and History.*

12. *Edgar Fripp House, "Tidalholm" (1 Laurens Street), ca. 1853.*

Edgar Fripp (1806–1860) also owned a plantation on St. Helena Island and 122 slaves. He was a justice of the peace and commissioner of Free Schools for Beaufort District. James Fripp, Edgar's brother, owned the house at the time of the Civil War. During the war, Union troops used the house as a hospital. After, the war, Tidalholm was a guesthouse for many years.

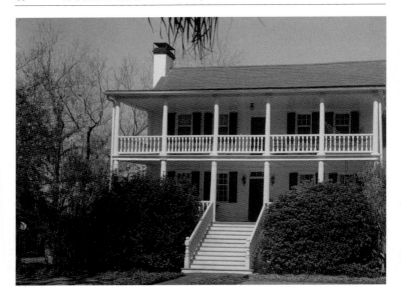

Elizabeth Hext House [Hext-Sams] (207 Hancock Street). *Courtesy of Library of Congress.*

13. Elizabeth Hext House, [Hext-Sams House], "Riverview" (207 Hancock Street), ca. 1780.

Elizabeth Hext (1746–1813) and her husband William Sams (who died in 1793) owned this house in addition to Datha Island, where they were early cotton planters. They left the island to their sons, Berners Barnwell and Lewis Reeve Sams, both of whom built stately homes on the Point. Riverview was sold for taxes during the Civil War.

14. John Archibald Johnson House (304 Pinckney Street), ca. 1850.

John Archibald Johnson was a planter, physician and a man, according to a contemporary, of great "individuality." Franklin Talbird, his brother-in-law, built this house. In 1860 Johnson was forty-one years old and owned real property valued at $25,000 and personal property worth $60,000. Johnson was in Confederate service at Fort Beauregard on Bay Point. When the fort on Hilton Head fell, he and the other troops on Bay Point evacuated their position, crossed to Saint Helena Island and made their way to Beaufort. In 1873 Johnson published accounts of his remembrances in *Beaufort and the Sea Islands, Their History and Traditions*.

John Joyner Smith House (400 Wilmington Street) peeks from behind massive live oaks. In 1862 Charlotte Forten, a free African American from Philadelphia, came to Beaufort to teach the former slaves. She wrote that she had never seen "anything more beautiful than these [live oak] trees." To her, "their great beauty consists in the long bearded moss with which every branch is heavily draped. This moss is singularly beautiful, and gives a solemn almost funereal aspect to the trees." *Courtesy of Jacob Helsley.*

Tour II

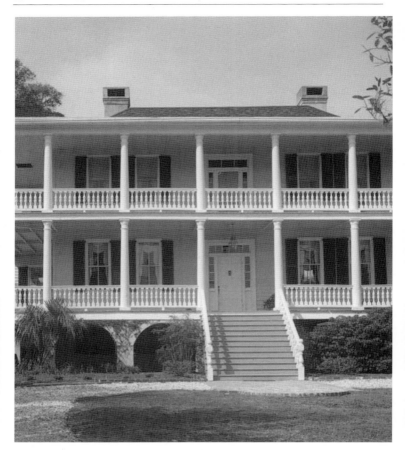

Thomas E. Ledbetter House (411 Bayard Street). From its antebellum owner, Ledbetter, the Methodist missionary, the house eventually became the home of the Christensen family. *Courtesy of Library of Congress.*

15. Reverend Henry Ledbetter House (411 Bayard Street).

Ledbetter was a Methodist missionary who was involved in the Methodist mission to aid Sea Island slaves. He frequently entertained other missionaries in his home. After the Civil War, Niels Christensen purchased the Ledbetter house. Christensen, a native of Denmark and Union veteran, was the first superintendent of the National Cemetery. His wife Abigail Holmes opened the first Montessori School in Beaufort. After the Hurricane of 1893, Clara Barton and the American Red Cross came to Beaufort to aid the survivors from the islands. Barton visited the Christensens during her time in Beaufort.

Chaplin House, ca. 1791 (712 New Street). The Chaplin House is one of the few surviving pre-1800 houses in Beaufort. *Courtesy of Jacob Helsley.*

16. John Chaplin House (712 New Street), ca. 1791.

The Chaplins were early planters who acquired 300 acres on St. Helena Island in 1733. In time, they added to their holdings. In 1790 another John Chaplin, the son of the first, owned 30 slaves. In 1825 John F. Chaplin filed tax returns showing that he owned 10 acres and 9 slaves in St. Helena Parish and 474 acres and 29 slaves in Prince William's Parish. The house has seen several renovations and additions.

17. Henry McKee/Robert Smalls House (511 Prince Street), ca. 1823.

In 1850 Henry McKee (1836–1875) was a thirty-nine-year-old planter. In addition to the house, McKee owned Ashdale Plantation and 105 slaves. He also served as a Beaufort town warden during the antebellum years. Robert Smalls, hero of the *Planter* and a United States Congressman, bought this house at a direct tax sale during the Civil War. Although Henry McKee had owned Smalls

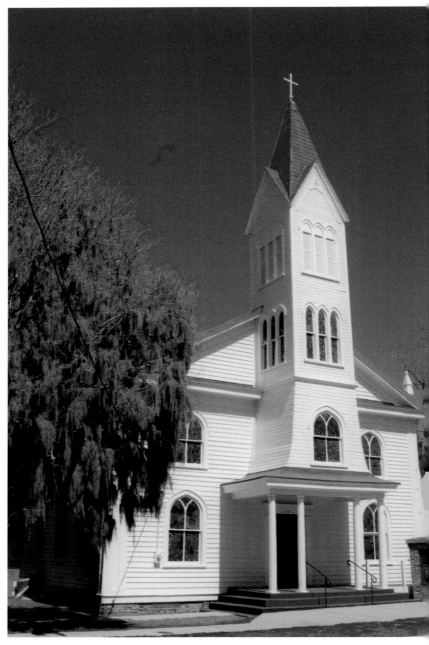

Tabernacle Baptist Church (907 Craven Street). The Baptist Church of Beaufort built Tabernacle in the 1840s as a meetinghouse. During the Federal occupation, a congregation of African American Baptists began meeting here. *Courtesy of Jacob Helsley.*

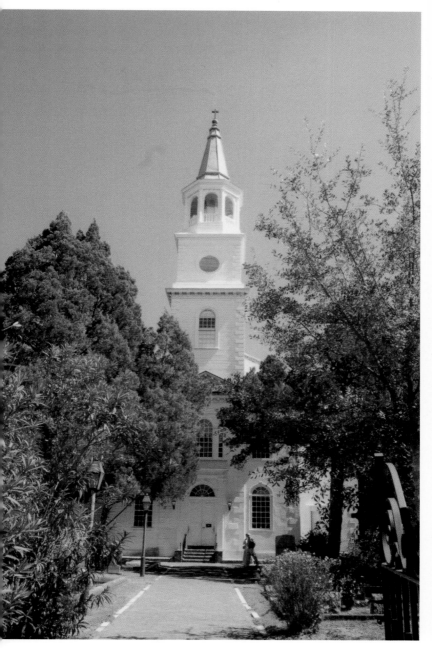

St. Helena Episcopal Church (501 Church Street). In a fifty-year span, forty-nine communicants of St. Helena's entered the ministry, including two bishops. In 1833, St. Helena had two Sunday schools with 98 white members and 234 African Americans. *Courtesy of Jacob Helsley.*

Henry McKee/Robert Smalls House (511 Prince Street). Home of Robert Smalls, the "Gullah Statesman." *Courtesy of Library of Congress.*

TOUR II

and his mother, at the time of the sale William J. DeTreville claimed ownership of the house. He protested the legality of the tax sale. The United States Supreme Court ultimately decided the case in Smalls's favor.

18. St. Peter the Apostle Catholic Church (710 Carteret Street), 1846.

Thanks to the efforts of the Irish-born Michael O'Connor, Catholics gained a place of worship. O'Connor, a native of Ireland, came to Beaufort in 1822. In the 1840s, he built a large house south of Bay Street. His property housed government offices during the occupation and became known as the Beaufort Hotel. The house later burned in 1925. O'Connor, a Bay Street merchant, is buried in the churchyard.

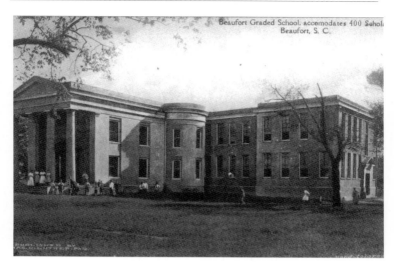

Beaufort College as Beaufort Graded School (Carteret Street). *Courtesy of Uel Jones.*

19. Beaufort College (800 Carteret Street), 1852.

Town leaders wanted educational opportunities for the town's young men. In 1795 the South Carolina General Assembly incorporated the college. The original trustees included such prominent residents as General John Barnwell, Colonel Robert Barnwell, William Elliott II, John A. Cuthbert, Reverend Henry Holcombe, William Fripp, John Mark Verdier and Dr. Thomas Fuller. The college faced many challenges and in 1817 even closed due to an epidemic of yellow fever. However, during the 1850s the college relocated and reopened. While it never achieved the grand goals of its original trustees, the college offered a solid preparatory education until the Civil War. For the first half of the twentieth century, the building housed elementary school classes. In 1959, it became the Beaufort Branch of the University of South Carolina. USC Beaufort has grown and expanded to include a second campus, but the Beaufort College building stands as a sentinel to Beaufort's long love of learning.

TOUR II

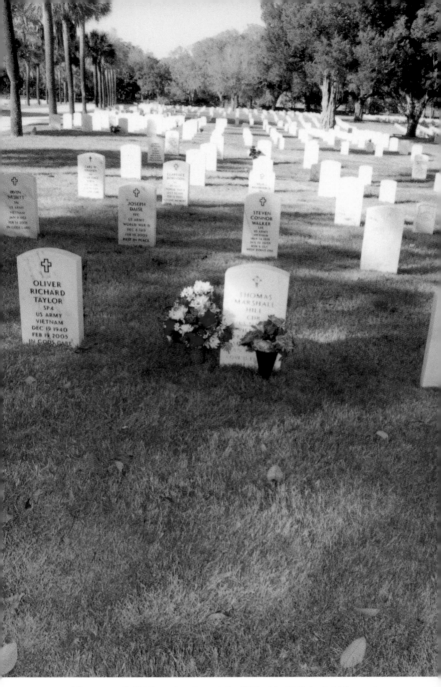

National Cemetery (1601 Boundary Street). Established in 1863, both Union and Confederate soldiers are buried here. *Courtesy of Jacob Helsley.*

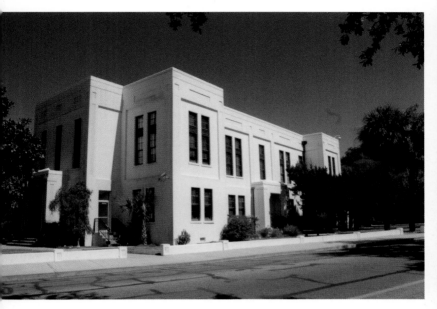

Beaufort Courthouse (1501 Bay Street). Many counties construct new courthouses, but few, like Beaufort, totally redesign theirs. The sleek art moderne lines replaced the Italianate tall windows and ornate entrance with balcony and columns of the original 1884 structure. *Courtesy of Jacob Helsley.*

The Beaufort River. In 1833 a visiting New Englander named Henry Barnard wrote: "Beaufort is a beautiful place—very quiet." *Courtesy of Jacob Helsley.*

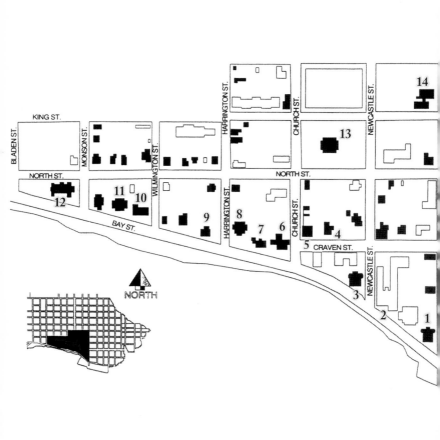

The Bluff

(BAY STREET WEST OF CHARLES STREET)

The Bluff is a neighborhood that lies west of the commercial center of Beaufort. This is an old section of town and several homes here predate 1800. For purposes of this tour, Bladen Street is the western boundary and Charles Street the eastern. The southern boundary is the river and the neighborhood stretches inland several blocks to King and Prince Streets.

Bay Street at the bend in the river looking east. Sir Charles Lyell, a well-known English scientist, visited Beaufort in December 1845. Sailing from Savannah, he commented on "the winding maze" of the Beaufort River. He found the area "novel and curious" and described Beaufort as "a picturesque town, composed of an assemblage of villas," each of which was "shaded by a verandah, surrounded by beautiful live oaks and orange trees laden with fruit." *Courtesy of South Caroliniana Library, University of South Carolina.*

Since the 1790s, the Bluff has been primarily a residential neighborhood. A number of handsome homes located on a high bluff enjoy unrestricted views of the Beaufort River. These are large houses on large lots—plantation houses brought to town! Houses along the bluff are spacious homes with their own grounds. Many of them originally had formal gardens. When Sir Charles Lyell visited Beaufort in 1845, he described the area as "an assemblage of villas" and noted the presence of live oak and orange trees. These houses face the river—the waterway that carried their crops to market and provided the revenue to pay for their construction. Not only are they well placed to view the river, but they are also prominently displayed for all who travel the river. The houses on the bluff are some of Beaufort's gems.

Construction began on the bluff before 1800. Several homes, such as Tabby Manse, date from the 1780s or 1790s. These homes reflect the economic resurgence of Beaufort after the devastation of the Revolutionary War.

On the eve of the Civil War, the residents of the Bluff neighborhood were some of the wealthiest in Beaufort. As historian Willie Lee

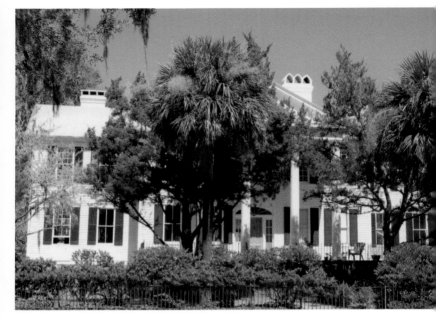

Edward Barnwell House, ca. 1815 (1406 Bay Street). Edward Barnwell, a descendant of John "Tuscarora Jack" Barnwell, may have built this house. During the Civil War, Union forces used the house as a signal station and telegraph office. *Courtesy of Jacob Helsley.*

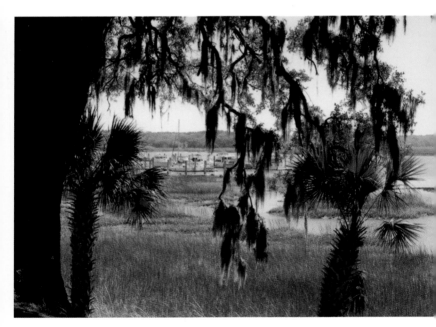

View of the Beaufort River, the lifeblood of early Beaufort, from the bluff. *Courtesy of Jacob Helsley.*

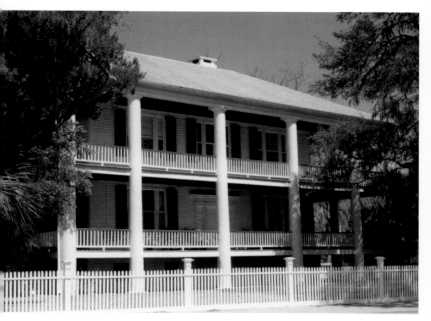

John Joyner Smith House (400 Wilmington Street). This house appears to face the bay, but the entrance is on the side. General Isaac Stephens, detailed to occupy Beaufort for the Union, made the John Joyner Smith House his headquarters. Smith was a highly successful planter whose Old Fort plantation was a few miles south of Beaufort. *Courtesy of Jacob Helsley.*

John Joyner Smith House gardens, corner or Wilmington and Bay Streets. Beaufort is a garden in the spring. *Courtesy of Jacob Helsley.*

Rose quoted in 1964, Beaufort was "the exclusive home of the most exclusive few of that most exclusive aristocracy." The style of the houses built here varied, and several notable ones, such as the Sea Island Hotel, no longer stand. Those that remain, however, provide a visual history of domestic architecture in Beaufort from 1790 to 1860.

Scene of Beaufort from the Bluff. Bathhouse opposite the Sea Island Hotel and warehouses are in the distance. *Courtesy of Uel Jones.*

Within walking distance of the fine houses are Beaufort's oldest houses of worship: St. Helena Episcopal Church, the Baptist Church of Beaufort and the Catholic Church of St. Peter the Apostle. The histories of these churches mirror the vicissitudes of the city of Beaufort. St. Helena, the oldest church in Beaufort, withstood British and Federal occupation. Both St. Helena and the Baptist Church of Beaufort served as hospitals during the Civil War. Both also benefited from the Second Great Awakening. Preaching of the noted evangelist the Reverend Daniel Baker in the 1830s sparked a revival that transformed the churches and the town. Baker preached at least three times a day and alternated between the churches. His preaching affected hundreds and, as a result, a number of Beaufort's young men entered the ministry. The increase in church membership also prompted rebuilding and expansion efforts as well.

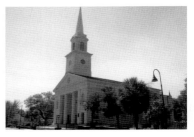

The Baptist Church of Beaufort (600 Charles Street). While Richard Fuller was pastor, the Baptists erected this sanctuary in 1844. Fuller was a famous Baptist preacher who left Beaufort before the Civil War to serve the Seventh Baptist Church in Baltimore, Maryland. *Courtesy of Jacob Helsley.*

Construction of St. Helena began in 1724 and its first steeple was added circa 1797. The structure suffered during the British occupation of Beaufort, from 1779 to 1782. The congregation completed the needed repairs in 1798. In 1817, members again enlarged the building and added a new steeple. After religious revival swept Beaufort in the 1830s, the congregation grew greatly, so much that the building was almost completely rebuilt in 1842. The current steeple dates from 1941.

The first Baptist church in Beaufort was probably a tabby structure built before 1800. In the 1840s under the leadership of the Reverend Richard Fuller the Baptists also experienced membership growth. The congregation demolished its original home after it was

St. Helena Episcopal Church (501 Church Street). *Luther's Pharmacy, courtesy of William Benton.*

declared structurally unsafe. In 1844, Fuller led the Baptists to erect the Greek revival structure that currently stands on the corner of Charles and King Streets. According to one account, Fuller refused to accept a salary from the church during his tenure there.

The old Beaufort County Courthouse, now the Federal Court House Beaufort District, marks the Bay Street terminus of the Bluff tour. Built in 1884, the courthouse was originally an elaborate Italianate structure. In 1936, the county had the exterior of the building revamped to its current art deco appearance. The courthouse stands on the site of Barnwell's Castle, an imposing three-story tabby structure that burned in 1881.

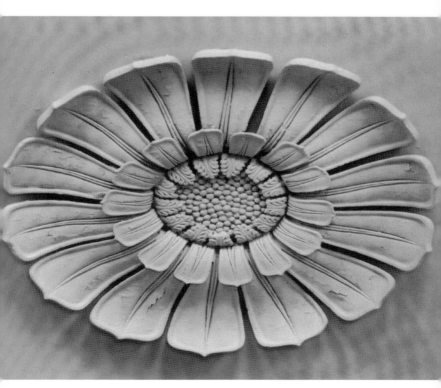

Nave ceiling rosette, Baptist Church of Beaufort. Plaster acanthus leaves and other decorative details adorn the ceiling of the Baptist Church of Beaufort. Slave craftsmen created these rosettes and leaves, some of the finest plasterwork in the city of Beaufort. *Courtesy of Library of Congress.*

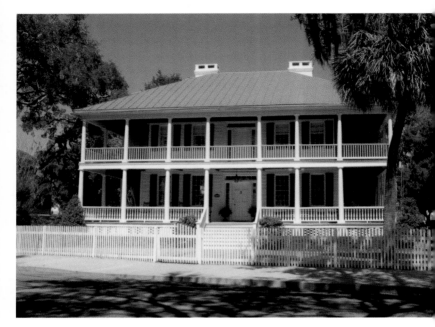

Charles Edward Leverett House (1301 Bay Street). Leverett, a native of New England and educated in Connecticut, came to Beaufort in 1831 as principal of Beaufort College. While in Beaufort, he married Mary Bull Maxcy and began to study for the priesthood. He was ordained in the spring of 1834 and in 1835 became rector of Trinity Church, Edisto Island. Eleven years later, in 1846, Leverett became rector of Sheldon Church, Prince William's Parish. Leverett purchased this Greek revival house in 1854. *Courtesy of Jacob Helsley.*

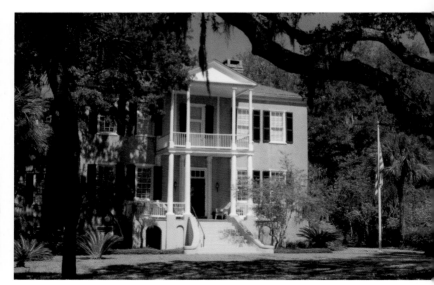

Thomas Fuller built "the beautifully proportioned" Tabby Manse, ca. 1786 (1211 Bay Street). Fuller's son, Richard, was pastor of the Baptist Church of Beaufort. *Courtesy of Jacob Helsley.*

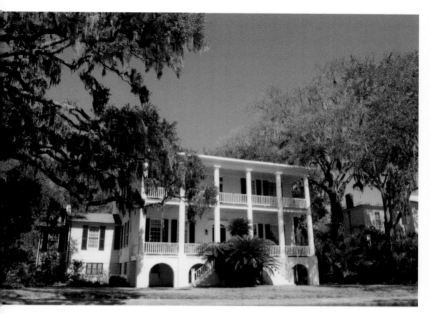

Robert Means House (1207 Bay Street). Means, a cotton planter on Parris Island, also served as Beaufort's intendant (mayor) in 1816. Major Edward Denby, President Warren G. Harding's secretary of the navy, bought the house in 1919. *Courtesy of Jacob Helsley.*

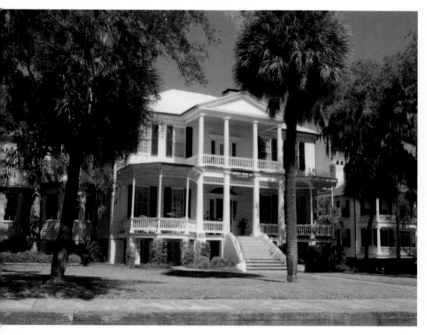

John A. Cuthbert House (1203 Bay Street). Cuthbert, as a representative from Prince William's Parish, signed the Ordinance of Secession in Charleston on December 20, 1860. *Courtesy of Jacob Helsley.*

George Parson Elliott House (1001 Bay Street). *General Thomas W. Sherman, who commanded the land forces during the battle of Port Royal, made this house his headquarters. Courtesy of State Historic Preservation Office, South Carolina Department of Archives and History.*

1. George Parsons Elliott House (1001 Bay Street), ca. 1840.

This property was the town house of George Parsons Elliott. In 1860 Elliott was a fifty-three-year-old-planter in Prince William's Parish. He represented that parish in the South Carolina House of Representatives and was commander of the Beaufort Volunteer Artillery. His lack of church attendance irritated his neighbor, the Reverend Charles Leverett. Dr. William J. Jenkins, a planter and physician, bought the house before the Civil War. In 1860, Jenkins owned real property, including Lands End Plantation on St. Helena Island, valued at $40,000 and personal property, including 138 slaves, valued at $90,000. In 1863 the house was sold for taxes.

View from the bluff looking toward Lady's Island and the bridge. Before the first bridge, a ferry connected Beaufort with the islands. The right to operate the Lady's Island ferry was a lucrative enterprise. Petitions to the South Carolina General Assembly highlight the competitive nature of different interest groups who jockeyed over control of the ferry. *Courtesy of Jacob Helsley.*

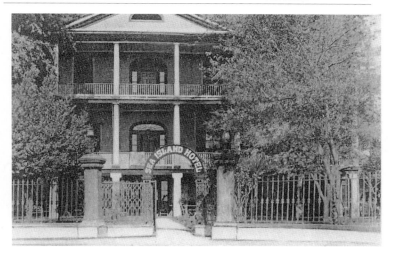

Sea Island Hotel (formerly at 1015 Bay Street). In 1870 Edward King visited Beaufort and noted that buzzards slept in front of the Sea Island Hotel. *Courtesy of Beaufort County Library.*

2. Site of the Sea Island Hotel (1015 Bay Street).

This is the site of the original Sea Island Hotel, which was razed in 1958. Dr. George Stoney (1795–1854) built the elegant original house. Nathaniel B. Heyward (1816–1891), who owned Whitehall Plantation on the Combahee River, acquired the property before the Civil War. Heyward was a trustee of the medical college in Charleston and served in the South Carolina House of Representatives and Senate.

The destruction of this historical building was an impetus for Howard Danner and others to organize the Historic Beaufort Foundation. Opposite the old hotel and extending into the river was a famous bathhouse. According to former Sheriff J.E. McTeer many young men learned to swim by being tossed into the river from the bathhouse.

TOUR III

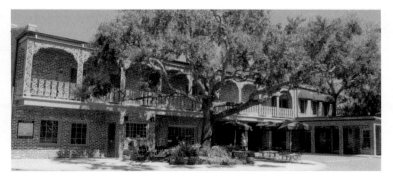

Best Western Sea Island Inn (1015 Bay Street). Site of the historic Sea Island Hotel. *Courtesy of Jacob Helsley.*

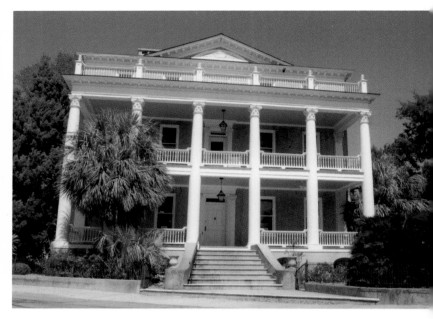

The Anchorage (1103 Bay Street). William Elliott (1788–1863) lived here in 1860. Elliott initially opposed secession and was the author of *Carolina Sports by Land and Water*. *Courtesy of Jacob Heisley.*

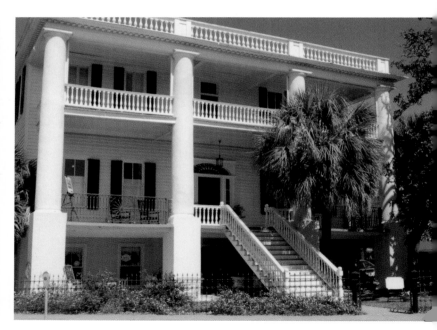

George Parsons Elliott House, ca. 1845 (1001 Bay Street). George Parsons Elliott was a member of the South Carolina House of Representatives. During the Civil War, Union forces used the house as a hospital. *Courtesy of Jacob Helsley.*

Wrought-iron detail, George Parsons Elliott House, 1001 Bay Street. *Courtesy of Jacob Helsley.*

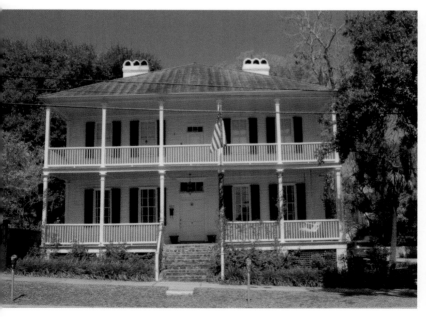

William Fickling House (1109 Craven Street) is the rectory for St. Helena Episcopal Church. According to the census, in 1800 Fickling was between twenty-six and forty-four years of age and lived in St. Helena's Parish. He owned thirty slaves. *Courtesy of Jacob Helsley.*

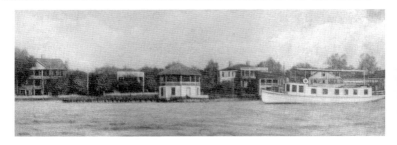

Waterfront view of Beaufort showing the Sea Island Hotel and the bathhouse. *Charles G. Luther, courtesy of William Benton.*

3. William Elliott House, "The Anchorage" (1103 Bay Street).

Several prominent men bore the name William Elliott. Either the first William Elliott or Ralph Emms Elliott (1764–1806) built this house in the 1790s or early 1800s. The second William Elliott, a leading Federalist in the 1790s, advocated fortifying the Beaufort area during the War of 1812. The third William Elliott (1788–1863) lived in the house at the time of the Civil War. This William Elliott served several terms in the South Carolina Senate, but resigned his seat in 1831 over the issue of nullification. A non-conformist, Elliott was a Unionist and opposed secession. However, when South Carolina seceded, he supported his native state.

Rear Admiral Lester Anthony Beardslee, a retired naval officer, later purchased the house, remodeled it and named it "the Anchorage." Beardslee died in 1903, but his widow Evelyn Smalls Beardslee (who died in 1923) was living in Beaufort as late as 1920. Beardslee commanded the USS *Jamestown*, which surveyed and mapped Sitka Harbor and Glacier Bay, Alaska, from 1879 to 1880.

4. William Fickling House (1109 Craven Street).

In the early 1800s, William Fickling built this house that since 1894 has served as the rectory for St. Helena Episcopal Church. Fickling was a schoolmaster and after his death in 1807, his wife sold the property.

5. Milton Maxcy House, "Secession House" (1113 Craven Street).

A building stood on this site by 1793 and by 1800 it housed a boys' school. Maxcy, a schoolteacher, operated the school. Edmund Rhett acquired the house circa 1860 and remodeled it to its current design. Edmund was one of the well-known Rhett brothers. The Rhett

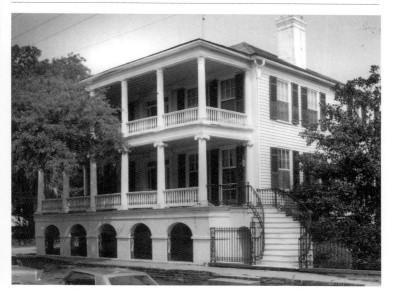

Milton Maxcy House, (Edmund Rhett) Secession House (1113 Craven Street). Edmund was a brother of Robert Barnwell Rhett, an early proponent of secession. During the 1850s, this house was the unofficial meeting place for those who advocated and worked toward secession. *Courtesy of State Historic Preservation Office, South Carolina Department of Archives and History.*

brothers were also famous for changing their surname from Smith to Rhett. In 1860 Edmund Rhett, a native of North Carolina, was a fifty-one-year-old lawyer and planter who owned real estate valued at $27,000 and personal property worth $75,000. Edmund's brother Robert Barnwell Rhett (1801–1882) was an early advocate of secession and held meetings advocating secession in the Maxcy House. Robert Barnwell Rhett, a graduate of Harvard, was a lawyer and planter. He served in the South Carolina House of Representatives, the United States Congress and the Confederate States Senate. He was also president of South Carolina College (later the University of South Carolina) from 1835 to 1841 and a signer of the Ordinance of Secession. In 1860, he owned two plantations in old Beaufort District and 157 slaves. After the Civil War, he was chair of the University faculty and, at the time of his death, college librarian.

6. *John A. Cuthbert House (1203 Bay Street).*

John Alexander Cuthbert, born 1790 in St. Helena Parish, built this house for his wife Mary B. Williamson, whom he married in 1811. John A. Cuthbert was one of the delegates from Prince William's Parish to the Convention to ratify the United States Constitution in 1788. He voted in favor. Ever civic-minded, Cuthbert was also one of

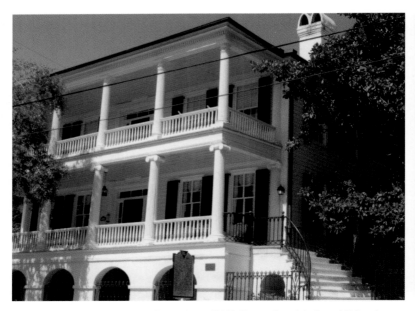

Milton Maxcy House/Edmund Rhett House (1113 Craven Street), built ca. 1815 and remodeled in 1845. *Courtesy of Jacob Helsley.*

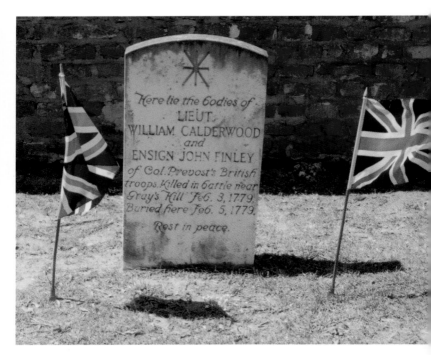

Burial site of Lieutenant William Calderwood and Ensign John Finley, British casualties, Churchyard of St. Helena's Episcopal Church (501 Church Street). *Courtesy of Jacob Helsley.*

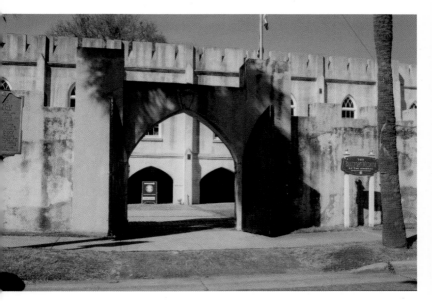

The Arsenal, 1852 (713 Craven Street). Home of the Beaufort Volunteer Artillery, a unit with roots in the American Revolution, the Arsenal has been rebuilt and remodeled. *Courtesy of Jacob Helsley.*

Henry Chambers Waterfront Park, 1990s. *Courtesy of Uel Jones.*

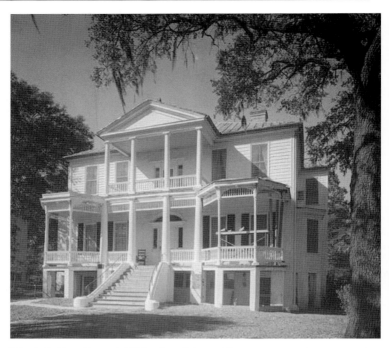

John A. Cuthbert House (1203 Bay Street). Altered from its antebellum appearance, the Cuthbert House was the home of General Rufus Saxton during the Union occupation of Beaufort. *Courtesy of Library of Congress.*

TOUR III

the original trustees of Beaufort College (801 Craven Street) in 1795. During the Civil War, General Rufus Saxton purchased the house at a direct tax sale reportedly for $1,000. When General William T. Sherman visited Beaufort en route from Savannah to Columbia, he spent the night of January 23, 1865, with Saxton in this house. Saxton was the military commander in Beaufort and involved in returning plantations to productivity, resolving labor disputes with the freedmen and developing a program to educate the freedmen— the so-called "Port Royal Experiment."

7. Robert Means House (1207 Bay Street), ca. 1790.

In 1816 as the newly elected intendant (mayor) of Beaufort, Robert Means helped quell an effort to eliminate municipal government in Beaufort. Opponents contended that government leaders only enacted taxes in order to spend the money. Means also owned a cotton plantation on Parris Island. During the Union occupation, the house was sold at a direct tax sale.

From 1919 to 1928, Edwin Denby (1870–1929), a native of Indiana, veteran of the Spanish-American War and former United States

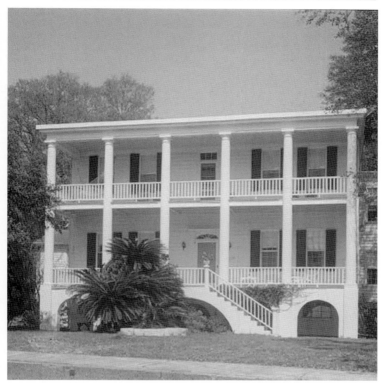

Robert Means House (1207 Bay Street). *Courtesy of Library of Congress.*

Congressman from Michigan, owned the house. President Warren G. Harding appointed Denby secretary of the navy. Denby held that appointment from March 4, 1921, until his resignation March 10, 1924, during the Teapot Dome scandal.

8. Thomas Fuller House, "Tabby Manse" (1211 Bay Street), ca. 1786.

Thomas Fuller, a planter, built this three-story Federal style tabby home. Fuller was the father of Richard Fuller. Richard Fuller, converted during the great 1830–31 revival, joined the Baptist Church of Beaufort and was called to be its pastor. In 1844, during his pastorate, the church built the present Greek revival sanctuary on Charles Street.

Reverend Mansfield French purchased the house during the Civil War. Later the Onthanks operated it as a guesthouse. Francis Griswold was a guest there while he wrote *A Sea Island Lady*. The novel set at Marshlands recounted the story of Emily Fenwick, the young wife of a carpetbagger, who moved to Beaufort after the

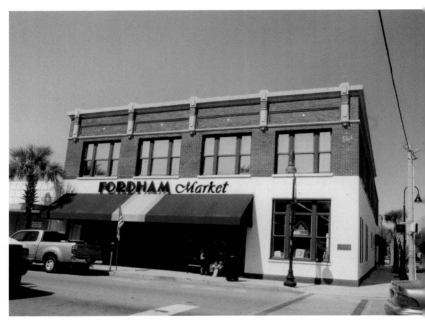

Fordham Market, formerly Fordham Hardware, corner of Bay and Carteret. *Courtesy of Jacob Helsley.*

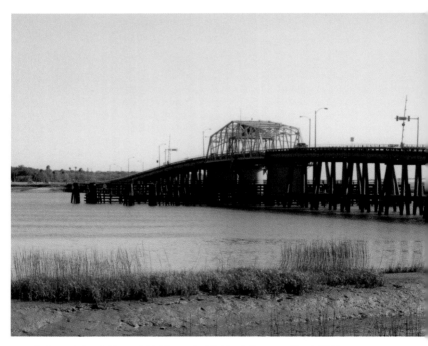

Richard V. Woods Memorial Bridge to Lady's Island. *Courtesy of Jacob Helsley.*

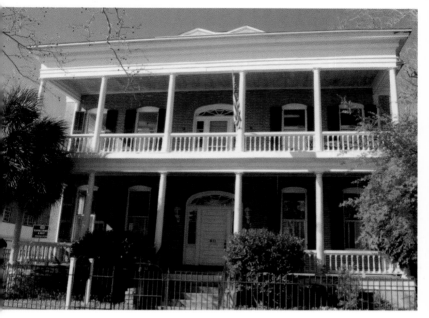

The Wallace House, 1909 (611 Bay Street), replaced the antebellum home once owned by Thomas Fuller destroyed by the 1907 fire. John Gordon, merchant, built the original house ca. 1800. *Courtesy of Jacob Helsley.*

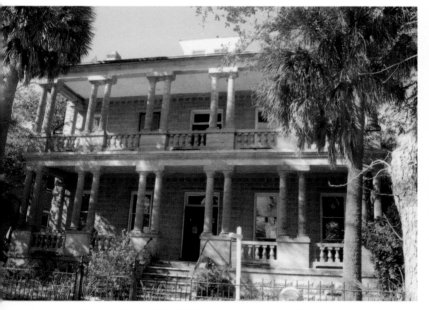

William Joseph Thomas House, 1909 (607 Bay Street), was rebuilt following the fire of 1907. Before the Civil War, the house that stood here was the home of Brigadier General Stephen Elliott, who died in 1866. *Courtesy of Jacob Helsley.*

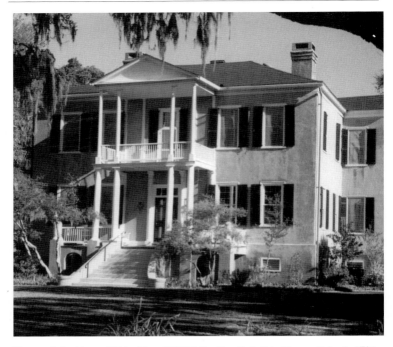

Thomas Fuller House, "Tabby Manse" (1211 Bay Street). Built by Thomas Fuller in 1786, in 1860 Dr. Henry Middleton Fuller owned this house. The Reverend Mansfield French later bought it at a direct tax sale. *Courtesy of Uel Jones.*

Civil War. In 1939 *Time* magazine reported that the publishers were confident that Griswold had written a bestseller.

Tabby Manse is one of the few structures remaining in Beaufort whose exterior walls are tabby. Originally, tabby was a mixture of oyster shells and limestone. In the nineteenth century, to strengthen the product, builders added cement to the mixture.

9. Charles Edward Leverett House (1301 Bay Street).

Charles Edward Leverett bought this early 1800s house in 1845. A native of New York, Leverett came south as a teacher, married and became an ordained Episcopal minister. He served as assistant rector of St. Helena Episcopal Church from 1856 to 1861. Following the battle of Port Royal, the Leverett family sought refuge on a farm near Columbia. A literate family, the Leveretts reared nine children and cultivated the art of letter writing. A compilation of their correspondence, *The Leverett Letters, Correspondence of a South Carolina Family, 1851–1868* offers an intimate look at Southern culture and life in South Carolina before, during and after the Civil War.

10. *John Joyner Smith House (400 Wilmington Street), ca. 1813.*

John Joyner Smith (1790–1872) built this elegant home and remodeled it circa 1850. Smith was the grandson of a sea captain who moved to Hilton Head from Georgia. Smith married Mary Gibbes Barnwell, but died without heir. His cotton plantation Old Fort (now the United States Naval Hospital) was the site of a great celebration honoring the reading of the Emancipation Proclamation on January 1, 1863. He also owned Blue Mud Plantation in St. Peter's Parish and, in 1860, 173 slaves. Smith was a wealthy planter and vestryman of St. Helena parish.

11. *Edward Barnwell House (1405 Bay Street).*

In 1780 British forces, following their capture of Charleston, imprisoned Barnwell, the Revolutionary veteran who built the house, on the prison ship *Pack-Horse* for over a year. Edward Barnwell (1757–1808) was a grandson of "Tuscarora Jack" Barnwell, a Beaufort area pioneer who helped defeat the Tuscarora Indians and save the colony of North Carolina in 1711. If Edward Barnwell built this house, he built it circa 1785. A recent architectural survey dated the house's construction to circa 1815.

At one time, Maude Odell Doremus, an actress who appeared in a number of plays including *Tobacco Road*, owned the house. After her death in 1937, James E. McTeer, longtime sheriff of Beaufort County, author and self-professed "root doctor," purchased this house.

TOUR III

Towering palmettos such as those that once lined the shell road leading into Beaufort partially obscure the Edward Barnwell House (1405 Bay Street). *Courtesy of Jacob Helsley.*

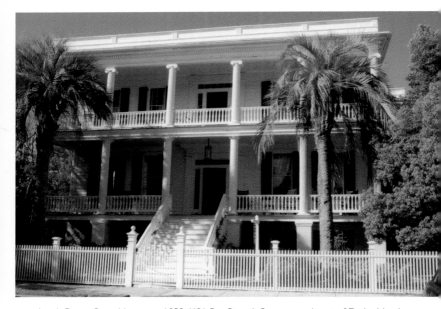

Lewis Reeve Sams House, ca. 1852 (601 Bay Street). Sams owned part of Datha Island. Occupying troops used his elegant town home as military headquarters and a hospital. *Courtesy of Jacob Helsley.*

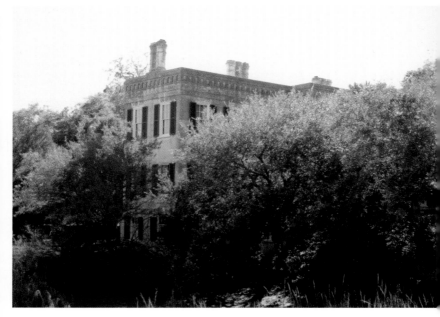

Joseph Johnson House, "The Castle," ca. 1850 (411 Craven Street). The Castle sits in "somber mystery" isolated from its neighbors by a small canal. *Courtesy of Jacob Helsley.*

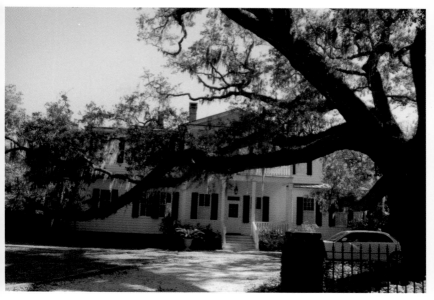

Paul Hamilton House, "The Oaks," north (rear) elevation (100 Laurens Street). Colonel Paul Hamilton built this house ca. 1855. He was the grandson of Paul Hamilton (1762–1816), who served as secretary of the navy under President James Madison and was a governor of South Carolina. *Courtesy of Jacob Helsley.*

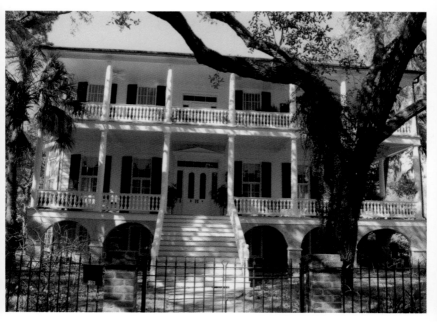

James Rhett House (303 Federal Street). James Rhett built this house on the Point between 1884 and 1886. *Courtesy of Jacob Helsley.*

12. Beaufort Courthouse (1501 Bay Street).

This was the site of an imposing three-story tabby structure known as Barnwell's Castle. Nathaniel Barnwell built the house circa 1770. Barnwell's Castle, although designed for domestic purposes, served as the Beaufort Courthouse from 1868 until its destruction by fire in 1881. After Barnwell's Castle burned in 1881, the county built an Italianate-style courthouse in 1884. In 1936 the county hired an architect, Willis Irvin, to remodel the courthouse. Irvin superimposed an art deco/art moderne façade over the original courthouse. Irvin, who grew up in Washington, Georgia, designed the Lincolnton, Georgia, Courthouse; Banksia and other homes in Aiken, South Carolina; and homes and shopping centers in Palm Beach, Florida. Today the old courthouse is home to the Beaufort District Federal Court.

13. St. Helena Episcopal Church (501 Church Street).

St. Helena is the oldest church in Beaufort. It is the parish church of St. Helena Parish, which the South Carolina Commons House of Assembly created in 1712. Church construction began in 1724, but subsequent congregations have rebuilt and enlarged the structure several times. The current steeple is the church's second one. "Tuscarora Jack"

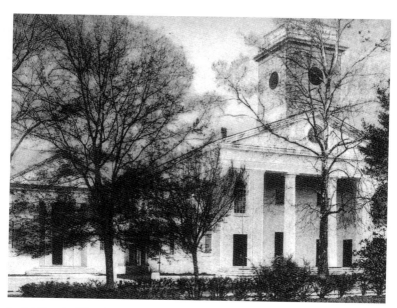

Baptist Church of Beaufort (Charles at King Streets). Built in 1844, this structure replaced an earlier tabby one. In 1848, the church had 2,282 members, only 195 of whom were white. *Luther's Pharmacy, courtesy of William Benton.*

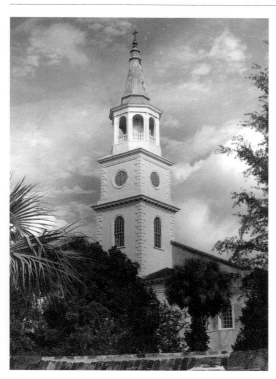

St. Helena Episcopal Church (501 Church Street) is the oldest church in Beaufort. Construction began in 1724. *Courtesy of Ned Brown, South Carolina State Historic Preservation Office, South Carolina Department of Archives and History.*

Barnwell and two British casualties of the battle of Beaufort are buried in the churchyard. The Reverend William Guy, the first rector, helped save the residents of Beaufort from a surprise attack by the Yemassee Indians in 1715.

TOUR III

14. Baptist Church of Beaufort (Charles Street at King Street).

Pastor Richard Fuller (1804–1876) led his congregation to erect this Greek revival edifice in 1844 after the church's first building proved unsafe. Fuller was a noted Baptist preacher. During his pastorate, the church's membership grew. At the time Fuller left for Baltimore, the church had 200 white members and 2,400 African American members. In 1847 he became pastor of the Seventh Baptist Church in Baltimore, Maryland. According to Lawrence Rowland's *The History of Beaufort County, South Carolina,* Richard Fuller was "one of the few white men to be accepted as a true spiritual leader of the sea island blacks." Although Fuller supported slavery, he opposed the sale of slaves and by 1851 was advocating the settlement of freed slaves in Africa.

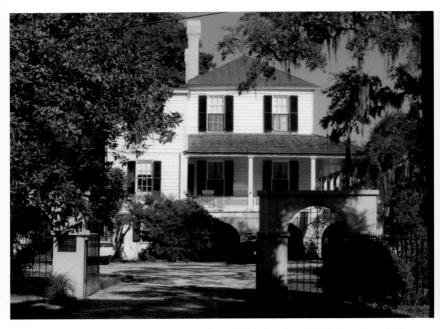

James Robert Verdier House, "Marshlands," east (side) elevation (501 Pinckney Street). Dr. James Robert Verdier was a son of John Mark Verdier, the Bay Street merchant. Dr. Verdier developed a successful treatment for yellow fever. *Courtesy of Jacob Helsley.*

General Edward Means House (604 Pinckney Street). In 1863 the Means House was hospital no. 2. Its two rooms housed sixty patients. *Courtesy of Jacob Helsley.*

The Green. This private park is a favorite place for neighborhood activities. *Courtesy of Jacob Helsley.*

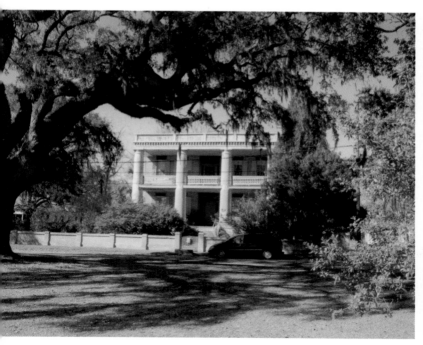

Berners Barnwell Sams #2 (201 Laurens Street). Dr. Berners Barnwell Sams built this house ca. 1852. This was the second house he built in Beaufort. *Courtesy of Jacob Helsley.*

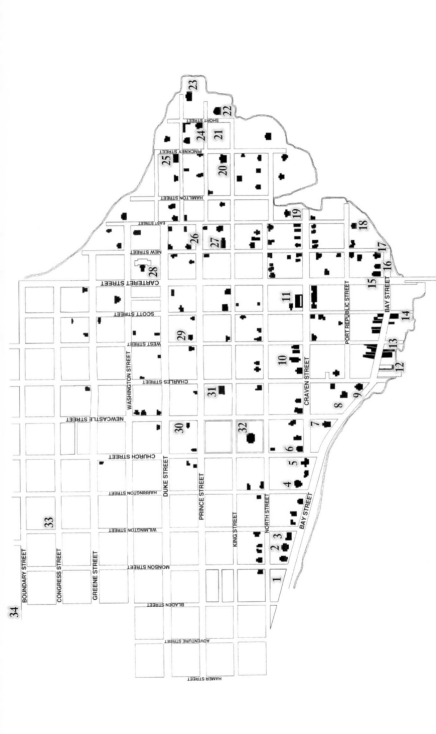

Civil War Beaufort

When South Carolina adopted the Ordinance of Secession in December 1860, Beaufort's residents embraced the Confederate cause. Many had been actively lobbying for secession for a number of years. Beaufort residents such as Robert W. Barnwell were leading "fire eaters." The Beaufort artillery entered state service and volunteers joined in preparations to defend the area. Residents were optimistic, but watchful. Beaufort's harbor and waterways—her natural advantages—made her a likely target.

In 1861, faced with maintaining an extensive blockade of the Southern coastline, the United States Navy needed repair and refueling facilities along the Atlantic seaboard. Naval staff members studied several sites before selecting Port Royal. In November 1861 a Union land and sea force massed to attack the area. Despite efforts to keep the operation secret, Confederates were aware of the planned attack.

The Port Royal expedition was a coordinated land and sea operation. Rear Admiral Samuel Francis DuPont led the naval forces,

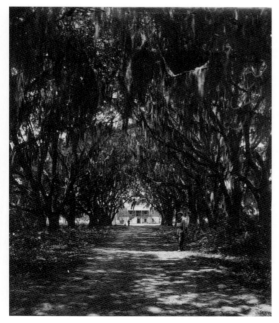

Live oak avenue of the Robert Barnwell Rhett plantation on Port Royal Island. Rhett was known as the "Father of Secession" for his outspoken efforts to foster secession. He was also a delegate to the Secession Convention and one of the signers. Jefferson Davis, however, did not offer him a cabinet position because many considered him an extremist. *Courtesy of Library of Congress.*

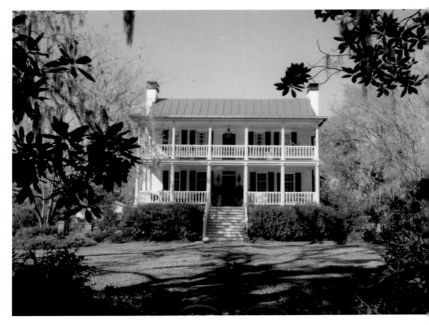

Elizabeth Hext House, "Riverview," (207 Hancock Street). Elizabeth Hext and her husband William Sams were Datha Island cotton planters who built this house ca. 1780. *Courtesy of Jacob Helsley.*

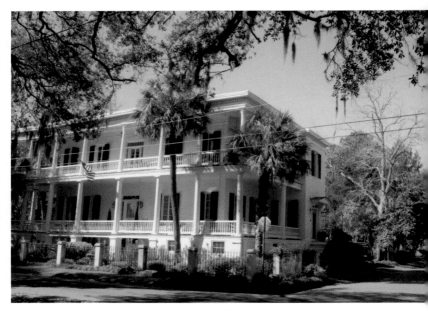

John Archibald Johnson House (804 Pinckney Street). John Archibald Johnson, planter and physician, built this house ca. 1850. His brother Joseph Johnson built the Castle a few years later. *Courtesy of Jacob Helsley.*

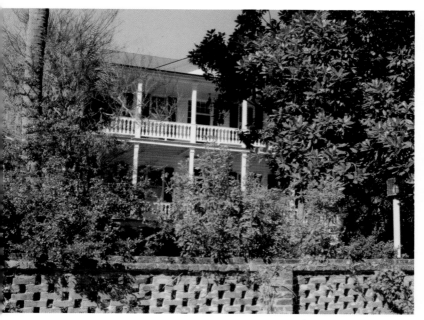

Henry McKee/Robert Smalls House, ca. 1834 (511 Prince Street). McKee owned Smalls and his mother Lydia as slaves. After his return to Beaufort, Smalls bought the house. Voters elected Smalls, a Civil War hero, to the United States Congress. *Courtesy of Jacob Helsley.*

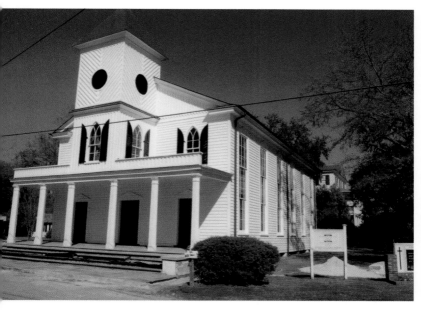

First African Baptist Church, ca. 1865 (601 New Street). African American Baptists organized First African Baptist Church during the Union occupation of Beaufort. This was the site of the Baptist Church of Beaufort's antebellum praise house. *Courtesy of Jacob Helsley.*

and Brigadier General Thomas W. Sherman, the land troops. Both DuPont and Sherman had ties to South Carolina. DuPont had often visited Grahamville in old Beaufort District and Sherman had been stationed at Fort Moultrie. When the fleet sailed, DuPont foresaw success for "so righteous a cause as ours, and against so wicked a rebellion."

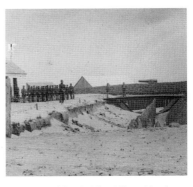

Rear view of Fort Walker, Hilton Head. Fort Walker was the stronger of the two Confederate forts that guarded the entrance to Port Royal Harbor. Its capture in 1861 placed Beaufort and the Sea Islands in Union hands. *Courtesy of Library of Congress.*

In addition to Fort Lyttleton south of Beaufort, the harbor's principal defenses were Fort Walker on Hilton Head and Fort Beauregard on Bay Point (Eddings Island). These forts guarded the entrance to Port Royal Sound. By sea, these forts were about 2.2 nautical miles apart. To protect the town of Beaufort, the Beaufort Volunteer Artillery constructed an earthwork west of town.

Despite a great storm at sea, the Union fleet persevered and achieved a great victory. By 2:00 p.m. on November 5, 1861, Fort Walker, the stronger position, was in Union hands and the battle of Port Royal was won. With the fall of Fort Walker, the men at Fort Beauregard retreated by way of St. Helena Island and finally reached Beaufort on November 7. The retreating troops found a deserted town. Dr. John A. Johnson, one of those retreating Confederates, could not find "one living creature, human or other, throughout the length and breadth of Bay Street."

No one knows why the white inhabitants of Beaufort abandoned their homes, slaves and prized possessions. Some allege that Confederate authorities ordered the evacuation; others state that there were no such orders. However, looking at Beaufort's history, flight had served the town's inhabitants well during the Yemassee uprising, and from prehistoric times, flight has been a natural response to danger. Also, Eugenia Ellis wrote in September 1861 that "People are already leaving Beaufort." Fear of attack led to false alarms, jittery nerves and early evacuations.

Regardless of the cause, the white population left the town and the Sea Islands. Most left their slaves behind. The field hands from the plantations, free of owner or overseer restraint, rushed into Beaufort and celebrated their newly found freedom. Some danced and partied while others ransacked the empty houses, according to General Isaac Ingalls Stevens, "smashing doors, mirrors and furniture, and appropriating all that took their fancy."

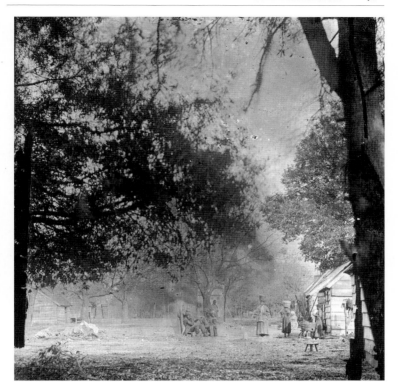

A plantation slave street on Port Royal Island. General Stevens estimated that fleeing owners left ten thousand slaves in the Port Royal area. Many Sea Island slaves lived in houses similar to these. *Courtesy of Library of Congress.*

Union troops moved up the Port Royal River and reconnoitered the town of Beaufort on November 9. Lieutenant (Jacob or William) Ammen was a member of the first landing party. He reported that there was only one white man in Beaufort, but "hundreds of negroes, wild with excitement" thronged the docks. DuPont went to Beaufort on November 12. He noted the "deserted" town—"a city in perfect preservation...bearing all the signs of the most recent habitation yet wanting the animation of ordinary life." He thought the inhabitants fled because they feared their slaves. Captain DuPont reported to the United States Secretary of the Navy Gideon Welles that

> *The people left their property in such a state as to show their precipitate flight was either the result of real terror or of a design to make it appear such...The deserted city and neighboring plantations exhibit a most melancholy example of weakness and dereliction from duty, the only excuse for which must be the well founded dread of a servile insurrection.*

TOUR IV

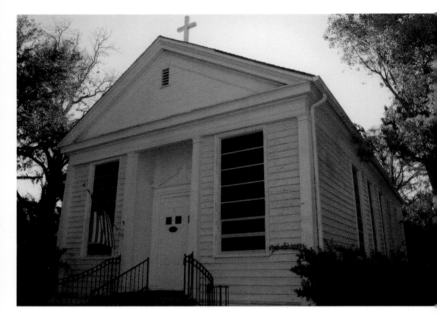

St. Peter the Apostle Catholic Church, 1846 (710 Craven Street). In 1846 Irish immigrant and successful Bay Street merchant Michael O'Connor built this church so Beaufort Catholics would have a place to worship. O'Connor is buried in the churchyard. *Courtesy of Jacob Helsley.*

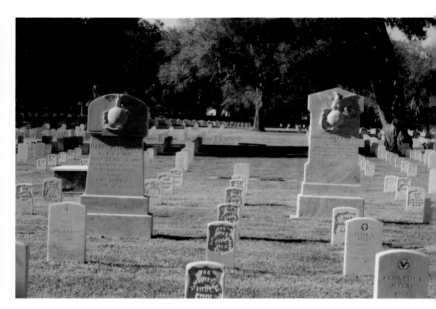

National Cemetery (1601 Boundary Street). This 1863 cemetery is the final resting place for veterans of many wars. In 1989, the remains of nineteen Union veterans from the Fifty-fifth Massachusetts Infantry were reburied there. Then-governor of Massachusetts and later presidential candidate Michael S. Dukakis participated in the service. *Courtesy of Jacob Helsley.*

Bay Street landscape looking westward with Francis Saltus House on the left. *Courtesy of Jacob Helsley.*

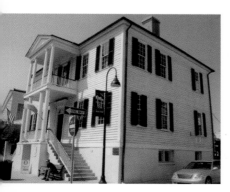

John Mark Verdier House, ca. 1801 (801 Bay Street). Verdier, of Huguenot descent, was a successful Bay Street merchant who entertained the Marquis de Lafayette during his visit to Beaufort. *Courtesy of Jacob Helsley.*

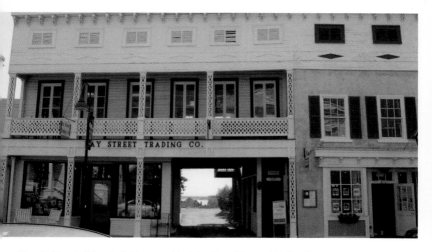

Captain Francis Saltus built his store (the John Cross Tavern, 812 Bay Street, on the right) in 1796. *Courtesy of Jacob Helsley.*

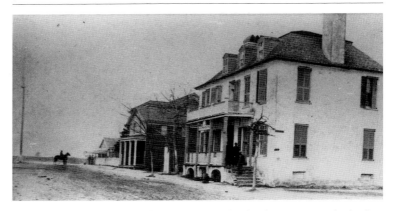

Civil War Bay Street. As late as 1870 visitors noted that Bay Street was so quiet that it seemed "the town was asleep." *Courtesy of South Caroliniana Library.*

Meanwhile, Union troops focused on establishing their position on Hilton Head and did not return to Beaufort until December. In the interval, some residents entered the town trying to recover items of value. One noted the wrecked organs at St. Helena Episcopal Church and the Baptist Church of Beaufort and the slave-occupied houses. Thomas Elliott found pillaged houses and furniture and other household belongings scattered in the town's streets. At his own home, he found some of his slaves dancing and playing the piano. Other planters returned to the islands, burned cotton and tried to intimidate their slaves into leaving with them. Eventually, Union troops under General Isaac Stevens occupied Beaufort to protect the roughly ten thousand slaves left on the Sea Islands.

On December 11, General Isaac I. Stevens, who had been ordered to occupy Beaufort, arrived from Hilton Head. With him were the Fiftieth Pennsylvania and Battery E of the Third Artillery. Union troops cleared all Confederate troops from the island and set up a temporary processing center and accommodations for the former slaves on the outskirts of town. Stevens secured the town's perimeter and placed its houses off limits to Union troops.

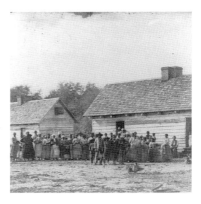

Stevens's headquarters was the John Joyner Smith house. In time, there was a signal station atop the Edward Barnwell house next door. Stevens, an honor graduate of West Point, had in

Former slaves on the John Joyner Smith plantation south of Beaufort. Many Sea Island planters such as Smith had large plantations in Beaufort District, but spent their summers in their town houses in Beaufort. *Courtesy of Library of Congress.*

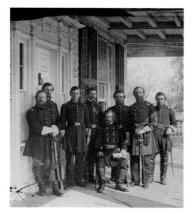

General Isaac I. Stevens (seated) with his staff at his headquarters, John Joyner Smith House (400 Wilmington Street), in Beaufort, March 1862. *Courtesy of Library of Congress.*

1853 been the first governor of the Washington Territory. On May 29, 1862, after five months, Stevens left Beaufort and was replaced by General Rufus Saxton.

Saxton was a short attractive man with abundant black hair and sideburns. During his tour of duty in Beaufort, he met Matilda Thompson, who had accompanied her brother, James G. Thompson, a teacher, to St. Helena. Described by Laura Townes as "the beauty of the island," Thompson charmed Saxton. In March 1863, Saxton and Thompson were married in St. Helena church. By that time, James G. Thompson was editing the *Free South.*

The military occupation changed Beaufort in many ways. Stevens fortified the "shell road" leading into Beaufort. Under Saxton, Union troops set up camp outside the town and in open areas throughout the town. A contemporary map showed tent encampments

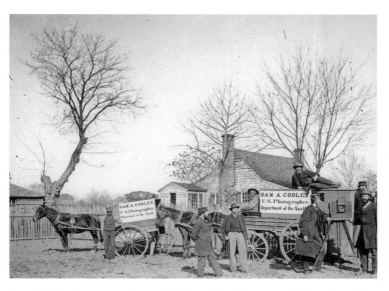

Samuel A. Cooley was one of several photographers that operated in Beaufort during the Union occupation. In 1863 he advertised his studio as west of the arsenal. Cooley also had a traveling studio, as shown in this photograph. The efforts of Cooley and other photographers offer a rare documentation of 1860s Beaufort. *Courtesy of Library of Congress.*

TOUR IV

Beaufort Bank (928 Bay Street). Around 1916 the bank was built on the site of the old post office. *Courtesy of Jacob Helsley.*

Abraham Cockcroft House (old Customs house) ca. 1857 (920 Bay Street). In 1899 on a Sanborn Company Fire Insurance Map, this building is first identified as the Beaufort Customs House. At other times in Beaufort's history, the structure was home to the telephone office and First Federal Savings and Loan Association. During the Union occupation, the Cockcroft and an adjacent property held the offices of the Post and Brigade. The Dock Dupont was immediately behind the property. *Courtesy of Jacob Helsley.*

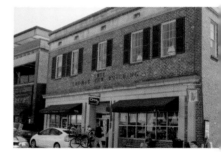

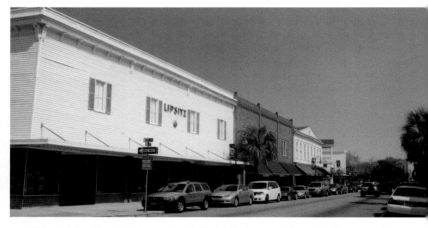

800 block, Bay Street looking eastward with Lipsitz Store and Keyserling Building on the left. *Courtesy of Jacob Helsley.*

throughout the town. Military departments, personnel and support organizations occupied the empty houses and the Bay Street businesses. Also, hotels, such as the Magnolia House, restaurants where soldiers could feast on ham, eggs, beans and apple pie for a dollar and similar service sector businesses opened downtown. In January 1863, a post office also opened on Bay Street.

The Sea Islands were the center of northern philanthropic efforts to educate and evangelize the former slaves. Known as the Port Royal Experiment, this was a public-private collaborative. Teachers and missionaries, called "Gideon's Band," flocked to the Beaufort area. Some lived in town and others on the islands. Their accounts shed light on life in Beaufort in the 1860s. Also, treasury officials and Freedmen's Bureau personnel were present. Treasury officials seized the abandoned property for non-payment of the direct tax.

In 1861 the United States Congress enacted a direct tax on all

St. Helena Churchyard (501 Church Street). The Lowcountry can be a deadly place. Mosquito-born illnesses, such as yellow fever and malaria, claimed many lives through the centuries. During the Federal occupation, the northern teachers and missionaries were not immune to the danger. The Fripp Mausoleum in the churchyard of St. Helena was often the temporary resting place for their temporal remains before the bodies were sent home. *Courtesy of Jacob Helsley.*

the states, including the eleven that had seceded, in order to raise money to finance the war. South Carolina's share of the tax was $363,570.66. Once the Sea Islands were in federal hands, tax agents came to Beaufort to collect the tax. Most owners did not pay the tax during the war years, so tax officials sold their properties for back taxes. The direct tax and the ensuing sales resulted in lawsuits and hard feelings, but reshaped land ownership in Beaufort and the Sea Islands.

The Freedmen's Bureau worked to provide housing, clothing, food, education and work opportunities for the freedmen. Both sets of officials—Freedmen's Bureau and treasury—wanted laborers for the cotton fields and wanted to see the plantations now in government hands profitable again. Enlisting laborers and negotiating compensation for their work were major challenges to restoring productivity on the sea-island cotton plantations.

The occupying forces raised two Union African American regiments— the First and Second South Carolina Regiments—in the Beaufort area. Thomas Wentworth Higginson commanded the First Regiment. Union

Men of the Fiftieth Pennsylvania Infantry in parade formation, Beaufort, February 1862. The Fiftieth Pennsylvania was the first regiment to occupy Beaufort. Organized on September 25, 1861, the Fiftieth included men from Berks, Schuylkill, Bradford, Susquehanna, Lancaster and Luzerne Counties. Assigned to Stevens's brigade, they accompanied General Stevens when he occupied Beaufort in December 1861. According to Samuel Bates, "on the night after the arrival a skirmish occurred in which the enemy was driven off the island not again to return." The regiment was also involved in fighting at Coosaw and Pocotaligo. On July 12, 1862, the regiment left Beaufort. *Courtesy of Library of Congress.*

African American soldier. Both the First and Second South Carolina Regiments of the United States Army were raised in the Port Royal area from 1862 to 1865. Thomas Wentworth Higginson, an abolitionist, commanded the First Regiment. In 1862, Arthur Sumner described the soldiers as "tall, fine-looking" and asserted that their "soldierly drill and bearing excites the respect of even their enemies." *Alfred R. Waud, courtesy of Library of Congress.*

officers encouraged and conscripted African Americans to enlist. Yet, many African Americans continued to live and work in Beaufort.

In addition to using many of the houses and buildings for official business and military headquarters, many homes and public buildings also served as hospitals. A map of Beaufort drawn circa 1863 for Dr. Clymer identified sixteen medical locations: fifteen hospitals and the chief medical office. Hospital sites were scattered throughout Beaufort, but a number were concentrated in the Bluff and Point areas. After being used as hospitals and for other military-related purposes, many of the houses and lots in Beaufort were sold for the direct tax.

The military establishment in Beaufort needed hospitals. The number of houses and churches

pressed into service testified to high Union casualties. Wounded flowed into Beaufort from fighting inland, around Charleston and to the south. In July 1863 the casualties from the assault on Fort Wagner arrived from Morris Island aboard the *Cosmopolitan*. The wounded from the Fifty-fourth Massachusetts Infantry were the first carried off the boat. A reporter for the *Free South* noted the "sad evidences of the bravery and patriotism" of the African American troops. There were so many wounded that it took over a day to unload the ship.

Detail of hospital no. 14—the Baptist Church of Beaufort—on ca. 1863 map depicting the military hospitals in Beaufort. *Courtesy of Library of Congress.*

On February 23, 1864, about 250 casualties from the battle of Olustee in Florida arrived in Beaufort. Thomas Wentworth Higginson, commander of the First South Carolina Regiment, described the scene:

> *Among the long lines of wounded, black and white intermingled, there was a wonderful quiet...[as] the shock to the system produced by severe wounds, especially gunshot wounds... usually keeps the patient stiller at first than at any later time.*

In January 1865 General William Tecumseh Sherman and part of his army arrived in Beaufort from Savannah, Georgia. Sherman's army had already conquered Savannah and was marching toward Columbia, South Carolina. The Tenth Army Corps marched into Beaufort. It took twenty steamships to transport the troops, supply wagons and artillery to Beaufort. On February 17, 1865, after its surrender to Sherman's army, much of Columbia, the capital of South Carolina, burned. The role of Sherman's troops in the destruction of the city is still a hotly debated issue.

Civil War Beaufort, boat landing, February 1862. Steamers and other watercraft carried visitors, missionaries and teachers to Beaufort and were the only avenues of communication between the town and the islands. There were several landings and docks in Beaufort, and many of the hospital sites also had docks for the landing of supplies and personnel. *Courtesy of Library of Congress.*

Some of the Union troops and support service personnel who came to Beaufort with the occupying army stayed. They

TOUR IV

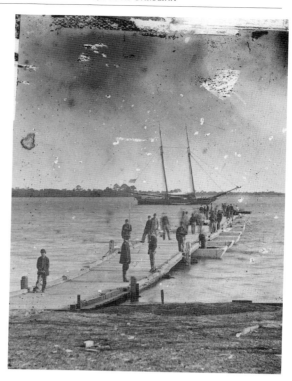

Federal troops
erecting a pontoon
bridge across the Port
Royal River, 1862.
*Courtesy of Library of
Congress.*

liked the area and saw economic opportunity. White and African
American veterans stayed. Some of the pre-war white inhabitants who
had left the town returned, and a number of them tried unsuccessfully
to reclaim their lost lives. However, many who left in 1861 never saw
Beaufort again. Or, if they did return, they only saw their old homes,
as Thomas B. Chaplin noted, "on a visit as strangers."

The Union forces renamed the Beaufort streets, brought new
construction methods such as prefabricated structures and
subdivided city blocks into smaller lots. So while the occupation
preserved, as in a time capsule, the beautiful antebellum homes, it
also sowed the seeds of change within the town.

This tour does not include all Civil War-related sites in the city
of Beaufort. Rather, its focus is on some of the more important
buildings and sites that illustrate the broad sweep of Union
activities in Beaufort during the Civil War. With a few exceptions,
the properties listed are contemporary with the Union occupation
of Beaufort. Notable exceptions are the sites of Barnwell's Castle
(now the Federal Courthouse), the Nathaniel Barnwell house
(later the Sea Island Hotel and now the Best Western Sea Island
Inn) and the Fuller and Elliott Houses at the corner of Bay and
Carteret Streets.

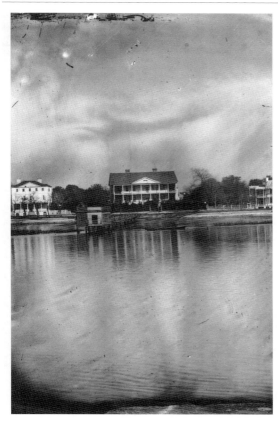

Nathaniel Heyward House, built ca. 1820, majestically surveys the Beaufort River in the 1860s. Seeing its natural eminence, General Rufus Saxton chose it as his headquarters. On January 1, 1863, following the reading of the Emancipation Proclamation and its attendant celebration, Saxton hosted a party for his staff and the schoolteachers there. Among the guests was "the beauty of the island," Matilda Thompson, whom he later married. After the Civil War, the house became a famous hotel known as the Sea Island Hotel. The house was razed in 1958. *Courtesy of South Caroliniana Library, University of South Carolina.*

1. Beaufort Courthouse, Site of Barnwell's Castle (1501 Bay Street).

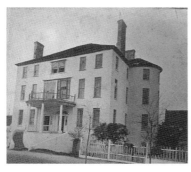

Barnwell's Castle (formerly at 1501 Bay Street). Colonel Nathaniel Barnwell built this imposing structure ca. 1779. From 1868 until its destruction by fire in 1881, Barnwell Castle served as the Beaufort County Courthouse. Thanks to Civil War photography, an image of this imposing structure survives. *Courtesy of Beaufort County Library.*

The current Federal District Courthouse occupies the site of Barnwell's Castle. Barnwell's Castle was an imposing three-story tabby structure built by Nathaniel Barnwell circa 1770. It served as the county's courthouse from 1868 until it was destroyed by fire in 1881. During the Civil War, Barnwell's Castle also served as hospital no. 5. Foundation walls of Barnwell's Castle lie beneath the present structure.

TOUR IV

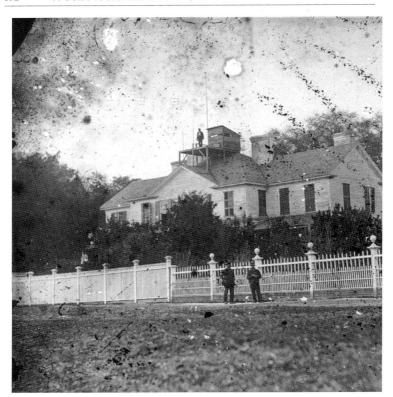

Federal signal station, formerly the home of Edward Barnwell, February 1862. Occupying forces used the signal station to maintain contact with the headquarters of the Department of the South on Hilton Head. *Courtesy of Library of Congress.*

2. Edward Barnwell House (1405 Bay Street).

Union forces erected a signal tower atop this house in order to communicate with the headquarters of the Department of the South on Hilton Head Island.

3. John Joyner Smith House (400 Wilmington Street).

General Isaac I. Stevens, the first occupying officer, made his headquarters here during his five months in Beaufort. His biographer described the house in December 1861 as "a fine mansion in the edge of town" that sat amid "a luxuriant semitropical garden with the Negro quarters and kitchens in detached buildings."

Stevens worked to secure the perimeter, to provide for the freedmen and to make safe and protect the abandoned property. He was particularly concerned with salvaging the books belonging to Beaufort's impressive prewar library. Unfortunately, Union officials

took the library northward, where fire destroyed it before the books could be returned. His son, Captain Hazard Stevens, accompanied the expedition and later wrote a biography of his father. The son and father were field and staff of the Seventy-ninth Regiment, New York Infantry. On September 1, 1862, General Stevens died in battle at Chantilly, Virginia.

4. *Thomas Fuller House, "Tabby Manse" (1211 Bay Street), ca. 1786.*

Dr. Henry Middleton Fuller who owned the house in 1860 left Beaufort after the battle of Port Royal. Dr. Mansfield French (1810–1876), a Methodist minister and abolitionist who initially came to Beaufort on a fact-finding trip for the American Missionary Society, purchased the house at a tax sale during the Union occupation. French's wife, Augusta, published *Slavery in South Carolina and the Ex-Slaves, or, the Port Royal Mission* in 1862.

Later owners the Onthanks operated it as a guesthouse. One of the sons of Thomas Fuller, who built the house, was Richard Fuller, pastor of the Baptist Church of Beaufort from 1833 to 1847.

5. *John A. Cuthbert House (1203 Bay Street), ca. 1810.*

The house served as hospital no. 9 during the Union occupation. At one point, General Saxton owned this double house. Among his more famous guests were General William Tecumseh Sherman fresh from his victorious entry into Savannah, Georgia, and en route to Columbia, South Carolina.

6. *William Elliott House, "The Anchorage," (1103 Bay Street).*

Much altered by later owners, this property was the home of the nonconformist William Elliott, who opposed secession. Once South Carolina seceded, however, Elliott, like General Robert E. Lee, rallied to the support of his home state. According to an 1863 map of Beaufort, this house was Union hospital no. 11.

7. *Sea Island Inn, Site of the Sea Island Hotel (1015 Bay Street).*

During the Civil War, this was the site of the Nathaniel Barnwell house. Dr. George Stoney built the house circa 1820. General Rufus Saxton

TOUR IV

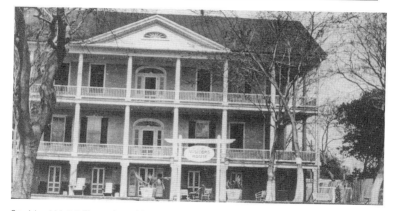

Sea Island Hotel (formerly at 1015 Bay Street). Dr. George Stoney built this house ca. 1820. Nathaniel B. Heyward (1816–1891) bought the property before the Civil War. *Courtesy of Beaufort County Library.*

used this house as his headquarters. To the east were the offices of the general superintendent of contrabands and plantations. The Barnwell House became the Sea Island Hotel until it was razed in 1958 to build a modern inn.

8. George Parsons Elliott House (1001 Bay Street), ca. 1845.

The house served as the headquarters for General Thomas W. Sherman and later as hospital no. 15. Sherman commanded the land forces for the joint land and sea invasion of Port Royal.

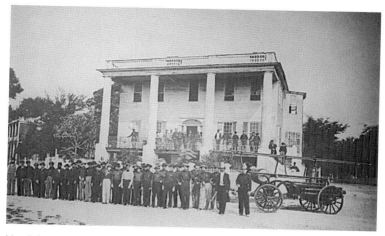

Hospital no. 15—George Parsons Elliott House (1001 Bay Street)—during the Civil War. *Courtesy of National Archives and Records Administration.*

George Parsons Elliott House (1001 Bay Street), headquarters of General Thomas West Sherman, Beaufort, with a military band on the steps, 1861–1865. General T.W. Sherman commanded the land forces for the joint naval and land invasion of Port Royal. The house was later used as a hospital. *Courtesy of Library of Congress.*

9. *Milton Maxcy House (1113 Craven Street).*

Known as the Secession House because of its connection with the Rhett family, the Milton Maxcy House saw a variety of uses during the war years. Officers from the 104th Regiment were billeted there. The house also housed a hospital, paymaster offices and even the office of the United States Direct Tax Commission.

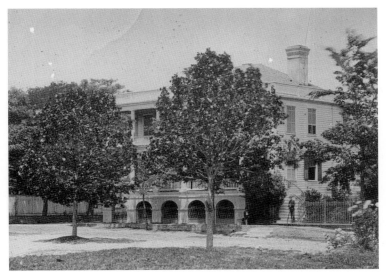

Milton Maxcy (Edmund Rhett) House, 1862 (1113 Craven Street). Federal troops used the house as a headquarters and for billeting officers. *Courtesy of Library of Congress.*

TOUR IV

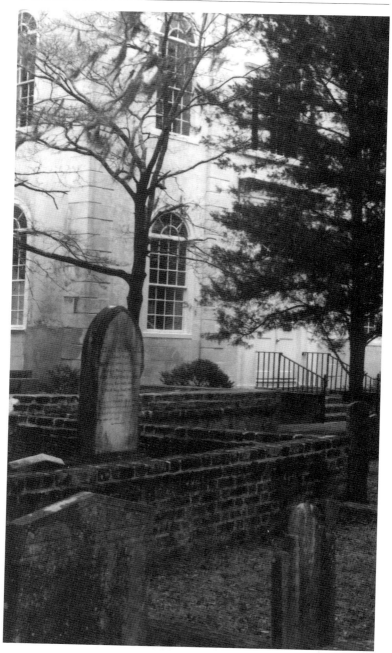

St. Helena Episcopal Church (501 Church Street). Brigadier General Stephen Elliott is buried in the St. Helena churchyard. *Courtesy of Beaufort County Library.*

10. St. Helena Episcopal Church (501 Church Street).

The church building, the oldest in Beaufort, was damaged during the Civil War. Prior to the arrival of Union troops, the church's organ was destroyed. During the occupation, Union forces floored over the balcony, removed pews and turned the church into hospital no. 12. Medical personnel also used tombstones from the churchyard as operating tables. Among the fallen Confederates buried in the churchyard is Brigadier General Stephen Elliott (1832–1866).

In March 1865 the church was the site of the marriage of General Rufus Saxton, military commander, and Matilda Thompson, "the beauty of the islands."

Union troops scratched their names on the walls of the church. Renovations in 1923 uncovered several of the names and other inscriptions. One of the names found was Wilber Dickerson. Dickerson was an eighteen-year-old farm boy in 1860 living in Rutland, Michigan. During the Civil War, he was drummer for company F of the Eighth Michigan Regiment.

11. Baptist Church of Beaufort (Charles at King Streets).

Confederate troops stationed a lookout in the church's belfry and Union troops used the church as hospital no. 14. To convert the church to a hospital, troops removed the pews and floored over the balcony. From photographic evidence, at some point, the church was also a hospital for African American troops. After the Civil War, pews, the communion service and communion table were found and returned to the church. The communion table had been in an office in Charleston.

Belfry of the Baptist Church of Beaufort (Charles at King Streets). A Confederate lookout used the belfry to watch for Union troops. According to a reporter, when Union troops entered the belfry, they found an empty decanter. Harper's Weekly, December 14, 1861, courtesy of the author.

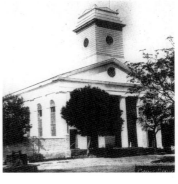

The Baptist Church of Beaufort (Charles at King Streets) was used as a hospital for African American soldiers during the Civil War. Courtesy of National Archives and Records Administration.

TOUR IV

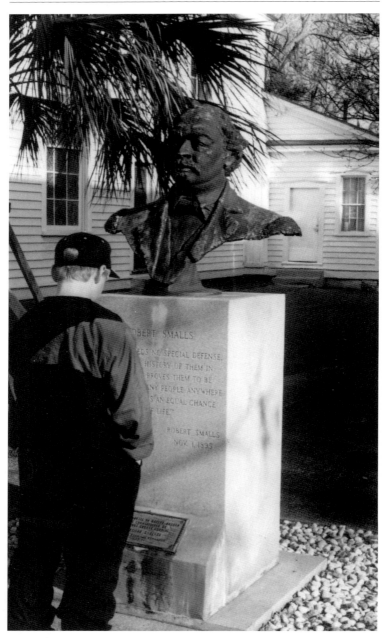

Monument to United States Congressman and hero of the *Planter*, Robert Smalls, Tabernacle Baptist Church (907 Craven Street). *Courtesy of the author.*

12. *Methodist Church (700 West Street).*

In 1849 Bishop William Capers dedicated this church for the Methodists of Beaufort. During the Civil War, with its white members gone, an African American congregation worshipped here. The church also housed a school during the war years.

13. *Grand Army of the Republic Hall (706 Newcastle Street).*

African American veterans of the Civil War organized the David Hunter Post no. 9 of the Grand Army of the Republic and erected this meeting hall circa 1896.

14. *Tabernacle Baptist Church (911 Craven Street).*

This church began as a praise house in the 1840s for the Baptist Church of Beaufort. During the Civil War, African American Baptists began to worship here as an independent congregation. Also during the occupation, the building served as a school. Robert Smalls, United States Congressman from Beaufort, is buried here and a monument honoring the "Gullah Statesman" stands in the churchyard.

15. *The Arsenal (713 Craven Street).*

This was the home of the Beaufort Volunteer Artillery, who volunteered for state service following South Carolina's ratification of the Ordinance of Secession. Stephen Elliott and other Beaufort residents served with this unit. Beaufort troops fought in the battle of Port Royal in 1861.

900 block of Craven Street with the Arsenal on the left. *Courtesy of Ned Brown.*

TOUR IV

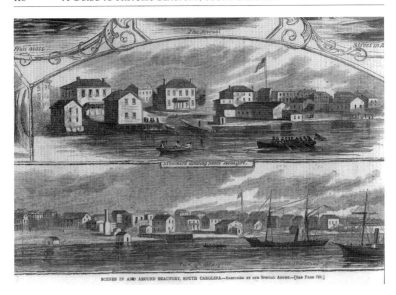

The Beaufort Waterfront shortly after Union occupation. Harper's Weekly, *December 14, 1861, courtesy of the author.*

16. *Chisholm House (905–907 Bay Street), ca. 1770.*

During the Union occupation, the Chisholm property was home to the post treasurer.

17. *Abraham Cockcroft House (920 Bay Street).*

The Cockcroft structure housed the offices of the post and brigade in front of the Dock Dupont.

18. *Francis Saltus House (802 Bay Street).*

The Saltus house, according to a contemporary photograph, housed a commissary for military personnel stationed in the area.

Also in the 800 block of Bay Street on the south side of the street were the John Cross Tavern (originally the Saltus store), where G.W. Woodmason, a native of Maine, operated a store, and the home of Michael O'Connor, a wealthy Irish-born merchant. In 1863 the provost marshal occupied part of the O'Connor House. Later it was the Beaufort Hotel. The O'Connor house burned in 1925.

Tour iv

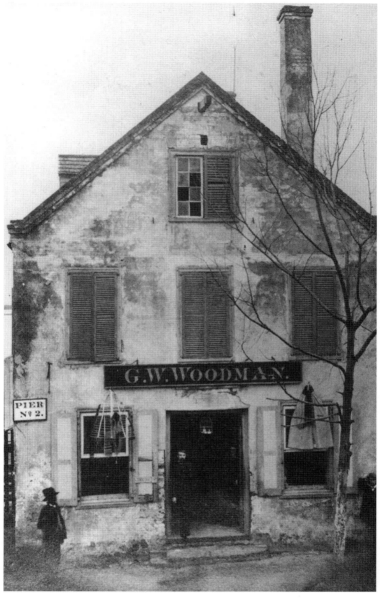

During the Civil War, George W. Woodman operated a store in the John Cross tavern on Bay Street. *Courtesy of South Carolina State Historic Preservation Office, South Carolina Department of Archives and History.*

TOUR IV

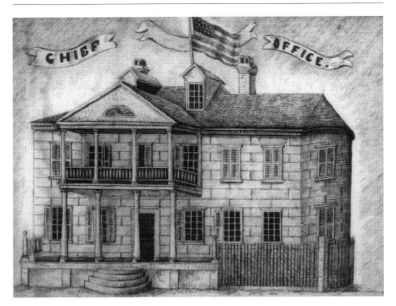

Chief Medical Office, ca. 1863. This building at the corner of Carteret and Bay Streets was the home of Dr. Thomas Fuller before the Civil War. John Gordon built the two-story tabby house ca. 1800. The fire of 1907 destroyed the house. *Courtesy of Library of Congress.*

19. Wallace House (611 Bay Street).

This was the site of the chief medical officer's headquarters in 1863, formerly the home of Thomas Fuller. At other times during the occupation, it housed the provost marshal, adjutant and quartermaster. The 1907 fire destroyed that house, and this replacement dates from 1909.

Civil War Beaufort landing. Left to right, the three houses to the rear on Bay Street were the Chief Medical Office (formerly the property of Thomas Fuller), the home of General Stephen Elliott and the Lewis Reeve Sams House, hospital no. 12. The 1907 fire destroyed the Fuller and Elliott Houses. *Courtesy of Beaufort County Library.*

20. William Joseph Thomas House (607 Bay Street).

The home of General Stephen Elliott stood on this site during the Civil War. That house was also a victim of the 1907 fire. In the summer of 1862, the dashing Captain Stephen Elliott (1832–1866), while serving with the Beaufort artillery with other Confederates, attacked and captured a Union outpost

on Pinckney Island. He was an officer of the Beaufort Volunteer Artillery, involved in the attack on Fort Sumter in 1861 and the defense of Fort Beauregard during the battle of Port Royal. General P.G.T. Beauregard appointed him commander of Fort Sumter. Later, the military transferred Elliott to Virginia, where in May 1864 he was promoted to brigadier general. Elliott was seriously wounded at the battle of the Crater near Petersburg, Virginia; he recovered, but was wounded again. He died February 21, 1866, and is buried in Saint Helena Episcopal churchyard.

During the occupation, the house was the headquarters for James G. Thompson's *Free South*, a newspaper. The editor's sister, as a result of a wartime romance, married General Saxton in March 1863.

21. *Lewis Reeve Sams House (601 Bay Street).*

At first, General Rufus Saxton, who succeeded General Isaac I. Stevens, made his headquarters here. A native of Massachusetts, Saxton had served as chief quartermaster on Hilton Head for General Thomas W. Sherman. Saxton later moved his headquarters to the Heyward House (later the Sea Island Hotel). The Sams House also was home to Union hospital no. 13.

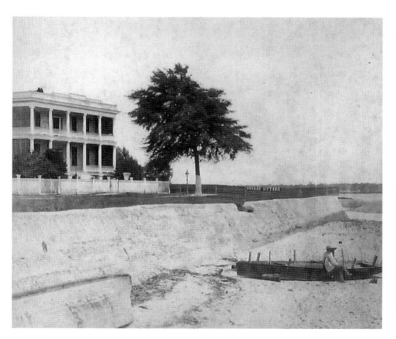

Civil War–era photograph of the Lewis Reeve Sams house with a portion of the tabby seawall. The Sams House served as General Saxton's headquarters and as a hospital during the Union occupation. *Courtesy of South Caroliniana Library.*

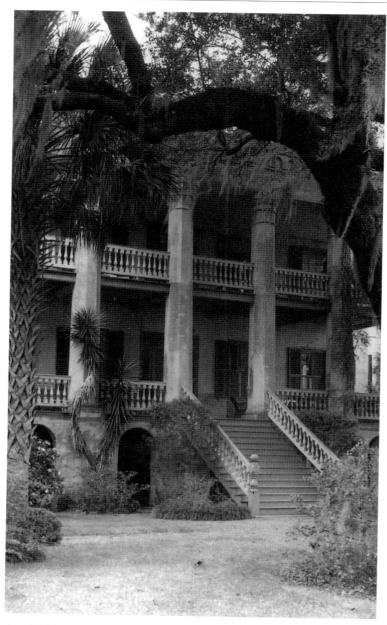

Joseph Johnson House, "The Castle" (411 Craven Street). During the Civil War, the house served as a hospital. Federal forces also used an outbuilding as a laundry and another as a morgue. *Courtesy of State Historic Preservation Office, South Carolina Department of Archives and History.*

22. *Joseph Johnson House, "The Castle" (411 Craven Street).*

The picturesque Castle served as hospital no. 6 and its outbuildings were used as a morgue and a laundry. In July 1863 hospital no. 6 housed approximately sixty-nine casualties from the fighting on Morris Island near Charleston, South Carolina.

23. *Paul Hamilton House, "The Oaks" (100 Laurens Street).*

Union forces designated the Oaks as hospital no. 1. In 1863 the property had a dock for the delivery of personnel and supplies. The hospital had seventy-seven beds and in July 1863 housed wounded from the One hundredth New York, the Sixty-second Ohio and the Sixth Connecticut.

24. *George Moss Stoney House (500 Port Republic Street).*

During the occupation, Union officers were billeted there.

25. *General Edward Means House (604 Pinckney Street).*

The Means house served as Union hospital no. 2. In 1863 it housed sixty patients in two rooms.

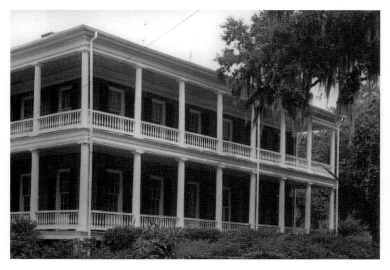

Edward Means House (604 Pinckney Street). General Edward Means built this "handsome" home ca. 1852. *Courtesy of State Historic Preservation Office, South Carolina Department of Archives and History.*

TOUR IV

THE POINT, BEAUFORT, S. C.

The Green, a private park in the Point. *Courtesy of Beaufort County Library.*

26. The Green (a city block bounded by Pinckney, King, Short and Laurens Streets).

The Green, an undeveloped island in the heart of the Point, is today a playground for neighborhood children. During the Union occupation, however, Federal troops created a mini-tent city on the Green. An 1863 map also showed two outbuildings on the site.

27. Berners Barnwell Sams House #2 (201 Laurens Street).

The Sams property housed hospital no. 8 with fifty-nine beds in 1863. Medical personnel cared for casualties from Folly and Morris Island here and in the Means house.

28. Edgar Fripp House, "Tidalholm" (1 Laurens Street).

The elegant Fripp house served as hospital no. 7 and housed Northern support staff. Edward S. Philbrick, an engineer from Boston, noted that he and others occupying the house kindled their fires with "chips of polished mahogany."

29. John Archibald Johnson House (804 Pinckney Street).

The Johnson House was part of a complex of several buildings, including the tabby house built by Colonel Thomas Talbird that burned in 1907. The Johnson House contained hospital no. 3. Only the steps of the Talbird House survive.

Edgar Fripp House, "Tidalholm," north (rear) elevation from the west (1 Laurens Street). For many years Tidalhom was a guesthouse. More recently, it was a featured location in *The Big Chill. Courtesy of Jacob Helsley.*

Johnson fought in the battle of Port Royal and was one of the first Confederates to visit Beaufort after the fall of Forts Walker and Beauregard. Following the Civil War, Dr. Johnson published his reminiscences of Beaufort and the Sea Islands.

30. *Henry McKee/Robert Smalls House (511 Prince Street).*

This was the birthplace of Robert Smalls. Henry McKee, who owned the house, also owned Lydia Smalls, the mother of Robert.

On May 13, 1862, Smalls gained national notice when he sailed the *Planter*, a Confederate transport steamer, out of Charleston harbor and behind Union lines. On board were Smalls, his wife and children and other slaves. The Northern press hailed him as a hero and the United States Congress granted him and his crew prize money for the *Planter*. Robert Smalls had a remarkable career. In 1863 the United States Navy gave him command of the *Planter*—possibly a first for an African American in the United States. Also, after the Civil War, Smalls became a major African American political leader in the Lowcountry and a member of the United States Congress. Known as the "Gullah Statesman," Smalls bought the McKee house at a tax sale and later provided support for his former mistress.

31. *First African Baptist Church (601 New Street), ca. 1865.*

In 1860 this was the site of a prayer house of the Baptist Church of Beaufort. During the Union occupation, a congregation of African American Baptists met here and organized an independent Baptist church.

TOUR IV

32. 1313 Congress Street.

This is an example of 1870s-era freedmen's housing. Housing for the freedmen was a pressing need, and many cottages were built in Beaufort and on the Sea Islands.

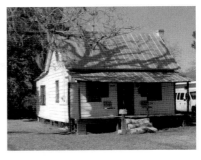

33. Beaufort College (800 Carteret Street).

Freedmen's style house, ca. 1870 (1313 Congress Street). In 1878 S.G.W. Benjamin wrote in *Harper's New Monthly Magazine* that most of the former slaves lived in "their former slave quarters or new and neat shanties or houses." *Courtesy of Jacob Helsley.*

Built in 1852, the old college building and the Elizabeth Barnwell Gough House (705 Washington Street) were part of a complex of several structures that functioned as hospital no. 10 during the Union occupation. Attempts to reopen the school after the Civil War were largely unsuccessful and the property became part of the Beaufort County School system.

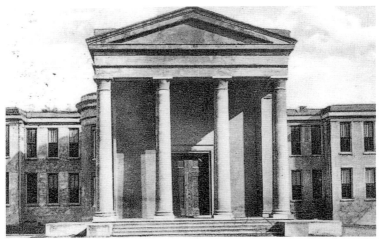

Beaufort College (800 Carteret Street). The University of South Carolina–Beaufort continues the educational dream of the Beaufort College trustees of 1795. *Courtesy of Beaufort County Library.*

34. National Cemetery (1601 Boundary Street).

Established in 1863, the cemetery is the burial site for veterans of American wars. Veterans of the Civil War, Spanish-American War, Korean, Vietnam and other wars are buried here. There are more than

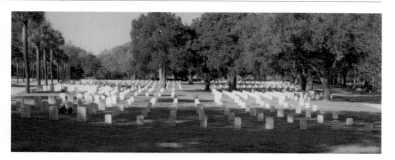

National Cemetery (1601 Boundary Street). Established in 1863, Captain Niels Christensen was superintendent from 1870 to 1876. *Courtesy of Jacob Helsley.*

7,500 Civil War soldiers interred in the cemetery, including over a hundred Confederates. As created, the cemetery has the shape of a half-wheel. The streets are the spokes and the iron gates were set in the hub. At first, the graves were marked with wooden headboards. Later, the administrators replaced the wooden markers with marble tombstones.

At the end of the central road, there is a monument to Union soldiers. Eliza McGuffin Potter (Mrs. Lorenzo Tucker Potter) erected the twenty-foot monument after the war ended. Potter and her husband personally nursed injured Union soldiers in the hospitals of Beaufort. The Potter Monument in section sixty-four lists the 175 men from eighteen states cared for by the Potters.

In 1989 the remains of nineteen members of the Fifty-fifth Massachusetts Infantry (an African American Civil War regiment) found on Folly Island, South Carolina, were reburied in the cemetery with full military honors. Then Governor of the Commonwealth of Massachusetts Michael Dukakis unveiled the Massachusetts Monument that honors the Fifty-fourth and Fifty-fifth Massachusetts Infantry Regiments and the Fifth Massachusetts Cavalry. In his remarks, Dukakis included a quotation from General William T. Sherman: "If it had not been for so much talk in Massachusetts and so much hot blood in Carolina, this war would not have come upon us." The movie *Glory* depicted Robert Gould Shaw and the Fifty-fourth Massachusetts at the assault on Confederate-held Battery Wagner in 1863.

Niels Christensen, a native of Denmark and Union veteran, was the first superintendent of the National Cemetery. He arranged to have the bodies of veterans collected from the Sea Islands and reburied there. He left the National Cemetery and became a successful businessman and political force in Beaufort. Among other enterprises, he ran a lumber mill on the Point and published the *Beaufort Gazette*. His wife, Abigail Holmes, was the daughter of abolitionists who came to Beaufort to aid the freedmen. She also opened the first Montessori School in Beaufort.

Maps

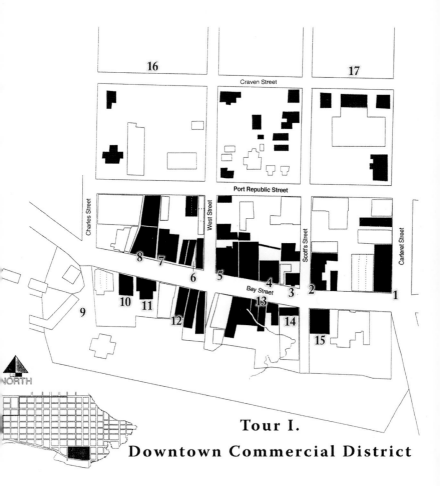

Tour I.

Downtown Commercial District

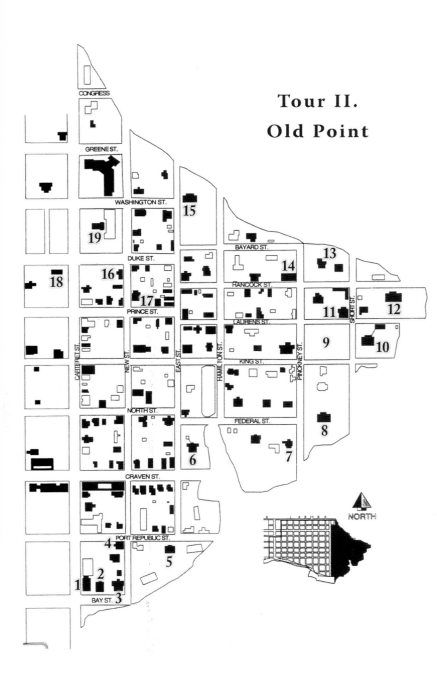

Tour II.
Old Point

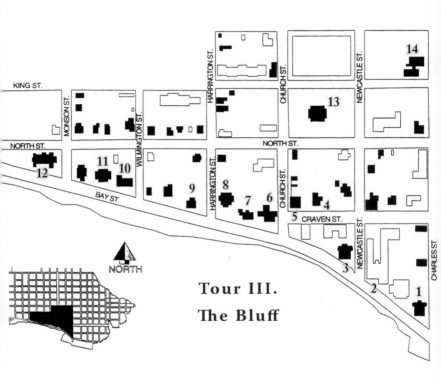

Tour III.
The Bluff

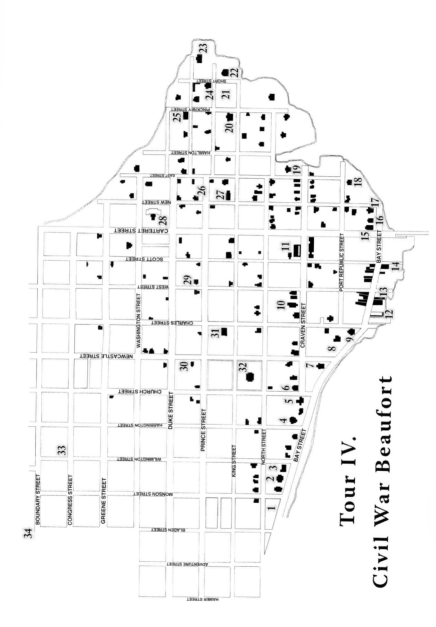

Tour IV.
Civil War Beaufort

Beaufort Timeline

1562
French Huguenot Jean Ribaut named Port Royal and established Charlesfort on Parris Island. When Ribaut did not return with needed supplies, the Frenchmen abandoned the fort.

1554–87
Spaniards explored and settled. From 1566–1576, Santa Elena on Parris Island was the capital of the Spanish province of La Florida.

1684
Yemassees from Florida relocated to the Port Royal area.

1684–86
Rise and fall of Stuart Town, a settlement of Scottish dissenters. The settlers there encouraged Yemassee depredations against Spanish missions. The Spanish at St. Augustine retaliated and wiped out the settlement.

1709
A delegation of early settlers asked the Lords Proprietors for a new town and port.

1711
The proprietors issued the charter of the town of Beaufort.

1712
South Carolina General Assembly created the parish of St. Helena.

1715
Yemassee War. The Yemassee, the Creek and other Native American groups mounted a major threat to the survival of the colony of South Carolina. The Yemassee destroyed the fledgling town.

1769
Circuit Court Act created administrative districts in South Carolina. Court for Beaufort District sat at Beaufort.

1772
Colonial legislature convened in Beaufort. This attempt by the Royal governor, Charles Montagu, to intimidate the rebellious Commons House was one of the royal abuses mentioned in the Declaration of Independence.

1779

Battle of Beaufort. Under William Moultrie, the Patriots repulse the invading British. Among the American militia were two signers of the Declaration of Independence, Thomas Heyward Jr. and Edward Rutledge.

1779–82

British forces under Major General Augustine Prevost occupied Beaufort.

1795

Beaufort College incorporated.

1803

The South Carolina General Assembly formally incorporated the town of Beaufort.

1850s

Time of economic vitality and construction. Residents built Beaufort College; homes such as the Castle, the Oaks and Tidalholm; and rebuilt the Arsenal.

1862

Battle of Port Royal; following the Union victory, white citizens abandoned the town and their plantations.

1862–65

Federal occupation. Port Royal Experiment brought education to the former slaves. Direct tax confiscations and sales provoked frustration and conflict for former owners and new purchasers.

1863

January 1, Emancipation Proclamation read at Old Fort Plantation near Beaufort.

1867–76

Reconstruction—a period of African American political involvement—and the beginnings of the phosphate industry in Beaufort County. African Americans maintained a political presence in Beaufort County into the early twentieth century.

1893

The storm of the century. A Category 3 hurricane and tidal wave struck the Sea Islands and left thousands dead and tens of thousands homeless.

1907
Major fire destroyed much of downtown Beaufort.

1924
Ku Klux Klan marched in Beaufort.

1956
Bridge to Hilton Head Island opened, inaugurating new era for the Beaufort area. Resort and retirement construction boomed on the Sea Islands.

1959
Hurricane Gracie (Category 4) struck Beaufort. The eye of the storm passed over St. Helena Sound.

1960s
Cold War fears fueled military construction and build-up in Beaufort County. Parris Island expanded; Naval Hospital added beds; Marine Corps air station upgraded; and Laurel Bay Housing Development for military personnel opened.

1967
Beaufort elected its first African American city councilman since Reconstruction, Joseph M. Wright.

1970–71
Beaufort schools were totally integrated.

1971–2005
Beaufort's library system expanded country-wide.

1974
The United States Department of the Interior designated Beaufort's historic district as a National Historic Landmark.

1975
City held groundbreaking for the Henry Chambers Waterfront Park.

Reading List

To learn more about Beaufort, consult these sources.

Helsley, Alexia Jones. *Beaufort, South Carolina: A History.* Charleston: The History Press, 2005.

Hilton, Mary Kendall. *Old Homes & Churches of Beaufort County, SC.* Columbia: State Printing Company, 1970.

Jones, Katherine M. *Port Royal Under Six Flags.* New York: Bobbs-Merrill Co., 1960.

Rowland, Lawrence C., Alexander Moore, and George C. Rogers Jr. *History of Beaufort County, South Carolina, 1514–1861.* Columbia: University of South Carolina Press, 1996.

Saunders, Roslyn, and Marquetta Goodwine. "African Americans in Beaufort." Beaufort: Historic Beaufort Foundation, 2000.

Taylor, Michael C. *Historic Beaufort County: An Illustrated History.* San Antonio, TX: Historical Publishing Network for the Beaufort County Historical Society, 2005.

Index

About the Author

A lexia Jones Helsley joined the South Carolina Department of Archives and History in 1968. She spent twenty years in the reference department, including twelve as supervisor. In addition, she served as director of public programs for eight years, director of education for two years, and as editor of the *Biographical Directory of the South Carolina House of Representatives*. Retired in July 2001, Helsley is currently developing a genealogical guide for the archives, teaching world and U.S. history at USC-Aiken, and managing a genealogical and historical consulting business. Her eight-part genealogical series *Branches* will air on SC-ETV's new South Carolina Channel in 2005. The series will be repeated later on SC-ETV and available for sale on DVD.

Helsley was graduated magna cum laude from Furman University; received her MA in history from the University of South Carolina, and completed doctoral coursework in public administration. She also was graduated from the Modern Archives Institute, National Archives and the South Carolina Executive Institute.

Among other publications, Helsley is the author of the following: *Researching Family History: A Workbook*; *The 1840 Revolutionary Pensioners of Henderson County; NC*; *Silent Cities: Cemeteries and Classrooms*; *Unsung Heroines of the Carolina Frontier*; *SC Secedes: a Drama in Three Acts*; *SC's African American Confederate Pensioners, 1923–1926*; and *South Carolinians in the War for American Independence*. In addition, she co-authored: *African American Genealogical Research*; *SC Court Records: an Introduction for Genealogists*; *The Changing Face of SC Politics;* and *The Many Faces of Slavery.* Helsley also compiled the historical data for the George F. Cram Company's *South Carolina Map.*

Helsley has lectured for the National Genealogical Society, the Federation of Genealogical Societies, and the Institute for Genealogy and Historical Research at Stamford University. She has also given presentations for the Society of American Archivists, the American Association for State and Local History, the National Association of Government Archives and Records Administrators, and the Council

on Public History. She is a charter member of the Henderson County Genealogical and Historical Society and currently serves as program vice president. Helsley is also president of the South Carolina Archival Association and a member of the National Genealogical Society, the Joseph McDowell Chapter, NSDAR, South Carolina Council for the Social Studies, and the South Carolina Historical Association.

She is a former president of Richland Sertoma and was named Richland Sertoman of the Year in 2000. In 2002 the South Carolina Archival Association honored her with a lifetime achievement award.

Married, Helsley is the mother of two children and active in her church, First Baptist Church of Irmo, South Carolina. An ordained deacon, she currently serves as church treasurer and on the church history committee. She and her husband Terry live in Columbia, South Carolina.

Also Available from the History Press.

Beaufort, South Carolina
A History
Alexia Jones Helsley
1-59629-027-7 • 256 pp. • $24.99

An evocative history of one of South Carolina's most significant small cities. Alexia Jones Helsley calls upon a lifetime of experience as one of the state's top historians to illuminate Beaufort's history through detailed research, compelling narrative and more than 120 photographs.

Also Available from the History Press.

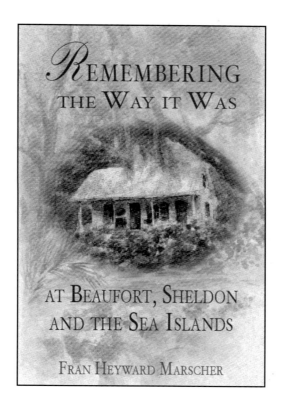

**Remembering the Way it Was
at Beaufort, Sheldon and the Sea Islands**
Fran Heyward Marscher
1-59629-136-2 • 128 pp. • $19.99

These delightful oral histories present a unique view of the past in a beloved section of the South Carolina Lowcountry, recalling times when turnips and scrawny chickens were accepted as legal fees and "Aunt Henrietta"—rumored locally to be an Italian princess—sailed her magnificent yacht right up the Beaufort River. Sure to amuse locals and visitors alike.

Visit us at
www.historypress.net